# IMAGES
*of America*

# SAN CLEMENTE

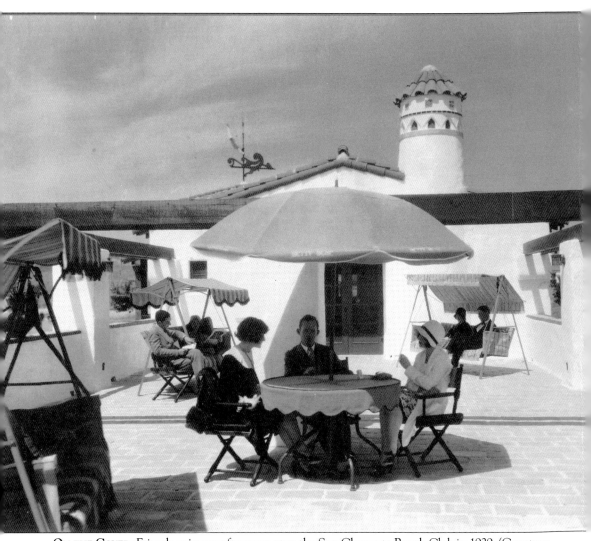

On the Cover: Friends enjoy an afternoon atop the San Clemente Beach Club in 1929. (Courtesy of the San Clemente Historical Society.)

# IMAGES of America
# SAN CLEMENTE

Jennifer A. Garey and
the San Clemente Historical Society

Copyright © 2010 by Jennifer A. Garey and the San Clemente Historical Society
ISBN 978-0-7385-8051-7

Published by Arcadia Publishing
Charleston, South Carolina

Printed in the United States of America

Library of Congress Control Number: 2009938745

For all general information contact Arcadia Publishing at:
Telephone 843-853-2070
Fax 843-853-0044
E-mail sales@arcadiapublishing.com
For customer service and orders:
Toll-Free 1-888-313-2665

Visit us on the Internet at www.arcadiapublishing.com

*Dedicated to the people of San Clemente*

# Contents

| | | |
|---|---|---|
| Acknowledgments | | 6 |
| Introduction | | 7 |
| 1. | The Beginning: Selling a Vision | 11 |
| 2. | The Outdoors: Golfing, Horses, Fishing, and Surfing | 43 |
| 3. | The Community: Family and Friends | 63 |
| 4. | The Visitor: Food, Lodging, and Commerce | 75 |
| 5. | The Parties: Events and Games | 101 |
| 6. | The Residences: Homes and Retreats | 107 |
| 7. | The President: When Nixon Moved In | 119 |

# Acknowledgments

So many deserve thanks in putting this book together. A huge thank-you goes to the San Clemente Historical Society, who graciously agreed to team together and allowed me to look through numerous photographs. Thank you to board members and committee chairs Mary Ann Comes, Mike Cotter, Lee and Dena Van Slyke, Dale Larsen, Georgette Korsen, Chris McCormack, Donald Prime, Bill Bluett, Lois Divel, Raad Ghantous, Larry and Jane Culbertson, and Jim Proett. A special thank-you to Pat Bouman for patiently putting up with my continual requests for photographs, even if it meant going into her personal collection. She has been an invaluable resource and an invaluable friend. Thank you, Mike Cotter, for believing in me and for sharing your insight and clear direction, while at the same time allowing me to fly. Thank you to G. Wayne Eggleston for sharing your profound love for San Clemente and its people. Thank you to Mary Ann Comes, whose strength is only matched by her wonderful smile, for her belief in this project and her commitment to the San Clemente Historical Society and the community. Thank you to Lee and Dena Van Slyke for your dedication in keeping the San Clemente story alive. Thank you to town matriarch Lois Divel for sharing her personal collection and her honest and thorough review of the text; many thanks to her family for their lifelong dedication to San Clemente. Thank you to Liz Hanson Kuhns, a beautiful soul with an infectious laugh, who patiently and gracefully reviewed the text, and who today embodies the generosity, strength, and vision of the Hanson family. She generously loaned images from her personal collections for inclusion in this book, a beautiful way to honor her family and the vision of Ole Hanson and the OHO. Thank you to Alex Forster, the late Dorothy Fuller, and Virgil Westbrook for their donations of photographs to the San Clemente Historical Society. Thank you to my friend Martha Collins for her amazing skills with the English language. Thank you to Debbie Seracini, Scott Davis, Devon Weston, David Mandel, and the staff at Arcadia Publishing. Without them, this would not be possible. All photographs are from the San Clemente Historical Society Archives, except as noted. The information contained in this book is derived from many invaluable sources: *The Story of San Clemente: The Spanish Village* by Homer Banks; *The Heritage of San Clemente* by Doris Walker; Lloyd Hanson's *Inside the Casa*; *From Fishcarts to Fiestas* by Blythe Welton and Mary Lou Nicolai; the Downtown Business Association's *The San Clemente Story*; as well as numerous news, notes, and recollections from John Hall, Patricia Hobbs Hendry, Fred Swegles, town patriarch Bill Ayer, and the people of San Clemente. Thank you.

# INTRODUCTION

*I vision a place where people can live together more pleasantly than on any other place in America. I am going to build a beautiful city on the ocean where the whole city will be a park; the architecture will be of one type, and the homes will be located on sites where nearly everyone will have his view preserved forever. The whole picture is very clear before me. I can see hundreds of white-walled homes bonneted with red tile, with trees, shrubs, hedges of hibiscus, palms, and geraniums lining the drives and a profusion of flowers illuminating the patios and gardens. I can see gay sidewalks of red Spanish tile and streets curving picturesquely over the land. I want plazas, playgrounds, schools, clubs, swimming pools, a golf course, a fishing pier, and a beach enlivened with people getting a healthy joy out of life.*

—Ole Hanson, 1925

The city of San Clemente, located on the Pacific Coast halfway between Los Angeles and San Diego, is a populous town with small-town appeal. The Acjachemen people were the indigenous population of the region. The area known today as San Clemente was occupied by the Spaniards, Mexicans, and Californios before California became part of the United States. Under Spanish occupation, San Clemente was the site of the first Christian baptism in North America when Father Crespi baptized two deathly ill Native American girls who lived in the area now known as Christianitos Canyon. Thomas F. Murphine, San Clemente's first mayor, lobbied for and acquired a monument for the site, declaring that California's historic landmarks were an important asset to the state, and "should be carefully preserved for future generations."

During the Mexican period, the area was part of the Pio Pico Rancheria. Don Juan Forster, a native of Liverpool, England, became a Mexican citizen while living in Los Angeles. He acquired the land in 1837 after marrying Dona Ysidora Pico, the sister of California governor Pio Pico.

San Clemente is unique geographically with its rolling hillsides, limestone cliff formations, and soft sandy beaches that drop quickly into underwater canyons. These geographical formations and a stable climate have given San Clemente an abundance of animal and sea life and have made the town appealing to everyone who has called the area home. One such person was the city's founder, Ole Hanson. San Clemente's beauty became fixed in his mind when he saw the area for the first time as he traveled north by train to his home town of Seattle, Washington. When the opportunity presented itself to build his dream city, Ole Hanson thought of the scenic area he had seen along the coast.

Ole Hanson, born in Wisconsin in 1874, had come west by way of Chicago, Illinois, and Butte Montana, searching for something more. He had tried his hand at sales; he was a legislator, a merchant, and mayor of Seattle, and was discussed as a possible presidential candidate.

Through Hanson's friend and associate Hamilton H. Cotton, Hanson was able to acquire the land that would become San Clemente. Cotton and 45 others held in trust land that belonged to Max and Herman Goldschmidt, who had acquired the land jointly with Cornelio Echenique, a member of the Forster family. The Goldschmidts, a family of distillers, suffered greatly during Prohibition, allowing the land held in trust with Cotton to be sold to Ole Hanson. In July 1925, Hanson's team began to survey streets, lots, and building sites on the town's first 125 acres.

The city of San Clemente was officially founded on December 6, 1925, and named after San Clemente Island, 45 miles off the coast. The city consisted of 125 acres of land and 6,000 feet of beach. Hanson envisioned the town as a Spanish-style coastal resort, a "Spanish Village." He was not satisfied with building average homes in a typical grid-like pattern or charging homeowners for city amenities as other developers of the day were doing. Hanson wanted his "Spanish Village" to have long, winding roads, following the contours of the hillsides, red tile on every roof, flowers in every garden, and views of the Pacific Ocean. Hanson had aerial photographs taken of the area to study the terrain. He chose picturesque locations for homes and convenient locations for businesses.

Horace Taylor, Ole Hanson's engineer followed by William Ayer, first superintendent of streets and city engineer, was baffled that Hanson would insist on a majestic road 80 feet wide; it was a unique request. Hanson envisioned it all. He personally walked with customers to lots and assisted in choosing the site for their homes. In another first, Hanson placed in each sale contract a clause requiring all plans be submitted to an Architectural Board for approval, and requiring all building exteriors to be in the Spanish Revival style, with white stucco and roofs of red tile.

Hanson felt so strongly in his dream that through the encouragement of his son Ole Hanson Jr., he began to sell his idea to potential buyers and future residents long before the first ground-breaking.

Starting on the day of the city's founding, December 6, 1925, in a rain-soaked sales tent, Hanson began to share his dream to others, describing a community that included a holistic belief in enriching the community by donating buildings to the people. Buildings were given to the city, including a social club, a hospital, and clinic, a beach club with a swimming pool, a public golf course, horse stables, bridle trails, a riding academy, and a baseball diamond. He even included electricity in all homes, in all public buildings, and on the street, all provided free of charge and deeded to the city for use by those who bought homes in the town. Hanson held meetings with potential buyers in his sales tent, but unlike the developers of the day, he did not make a sales pitch. Instead he let the potential buyers into his vision, and he shared with them the costs and budget breakdowns of his dream. He made every potential buyer feel like a member of his club, a part of his dream. In a letter to a friend, Hanson wrote, "I want people to have more than a piece of land; I want them to have location, environment, development. I feel that my past success in real estate will assure them of future prosperity here, and I feel that by giving people a chance to live intelligently and artistically I may possibly influence other builders to help. I do not want people to be repulsed and sent away by ugliness in San Clemente. This will be a place where a man can breathe. I have a clean canvas and I am determined to paint a clean picture. Think of it as a canvas five miles long and one and one-half miles wide."

On the very first day he had sold over $125,000 worth of lots and shared his vision with over 1,000 people. True to his word, Hanson provided everything he promised and more, including a school valued at over $30,000 and a Spanish-style plaza outfitted with a lake and swans, a water system valued at over $500,000, and a 1,200-foot fishing and pleasure pier, all gifts to the city. Within one year, home sales were over $3 million, and the building demand required 16 homes be built every week. By January 1927, Ole Hanson had increased sales to a total of $7.5 million. Carleton M. Winslow, renowned Spanish Colonial Revival building architect and landscape architect, said of San Clemente, "It grows more beautiful in a way to appeal to European eyes familiar with such picturesque quality in their towns. American eyes do not see it yet."

Ole Hanson's success was not only due to the beauty of the area he so frequently pointed out, but to the people he surrounded himself with. His vision could never have become a reality

without the dedicated and committed people he had around him: Hamilton H. Cotton and the 45 investors who controlled the land trust and who decided to take the risk to back Ole Hanson's dream; Horace Taylor and William Ayer, engineers who laid out the plan; and architects and designers such as J. Wilmer Hersey, Richard Sears, Carl Lindbom, W. E. Hill, and Virgil Westbrook, who in keeping with Hanson's vision designed beautiful, elegant, and functional homes in the Spanish Revival style. And Hanson's team of sales people and confidants helped as well: his son Ole Hanson Jr., Edward Bartlett, Scotty Watson, Trafford Huteson, Hugo Carlson, and his friend of 25 years, Thomas F. Murphine.

As demand increased, the firm of Huteson and Murphine focused on sales. Professor Leonard G. Nattkemper provided information on the area and Hanson's vision. Hugo Carlson took care of the budget and organizational affairs. This became known as the Ole Hanson Organization (OHO). After one year with the OHO, each person received a gold ring. Each subsequent year, a ruby was placed in his or her ring.

Ole Hanson believed so strongly in his vision that he would not be swayed even by the county when San Clemente's streets were denied. In an unprecedented move, Hanson became the owner of the city's streets by filing the city map as a surveyor's map. He paid taxes on the roads himself until the city incorporated in 1928, when he sold all the streets to the city for $1.

San Clemente incorporated in 1928 with a council-mayoral government. Ole Hanson Jr., Thomas F. Murphine, Oscar F. Easley, Earl Von Bonhorst, and Leroy M. Strang were elected as city council members, with Thomas Murphine chosen mayor. The duties assigned to each were Mayor Murphine, commissioner of finance; Oscar Easley, commissioner of streets and sidewalks; Ole Hanson Jr., commissioner of lights, water, parks, and playgrounds; Leroy M. Strang, commissioner of police and fire departments; Earl Von Bonhorst, commissioner of health, safety and public morals; William J. Berry, city clerk; Harry H. Cavin, city treasurer; L. G. Nattkemper, city recorder; Charles D. Swanner, city attorney; Forest J. Eaton, chief of police; James H. Bennett, chief of the fire department; William A. Ayer, superintendent of streets and city engineer; and Edward R. Bartlett, electrical, plumbing, and building inspector.

By the summer of 1929, a million cubic yards of dirt had been excavated; 40 miles of streets had been paved; 49 miles of water pipes had been laid; 6 million square feet of pavement laid, 31 miles of gutter and 65 miles of curb laid. Some 31 miles of Ole Hanson's Spanish tile had been placed into the sidewalks.

The new city owned free and clear all of its streets, five miles of beach, 1,200-foot fishing pier, community club house, beach club and pool, schoolhouse, golf course, bridle trails, tennis courts, playgrounds, and its landscaping and water system.

The city was impacted by the Great Depression as all cities were; however, San Clemente was able to survive because homeowners' amenities had been paid for by OHO. The city known by its neighborliness applied this attitude during the Prohibition. As San Clemente's pier provided a perfect drop-off location, many began a profitable business in bootlegging or rum-running. All the while, San Clemente's elite such as Hamilton Cotton, one of Hanson's partners, hosted Pres. Franklin D. Roosevelt for card games in his small gazebo outbuilding overlooking the Pacific Ocean. In the early 1940s, the Spanish village lifted the restrictive Spanish Revival building codes established by Ole Hanson, and the first ranch-style homes were built. In the late 1930s, the San Clemente State Park, begun through the Civilian Conservation Corps, was established and is still enjoyed by residents and visitors alike. With the end of the Depression, San Clemente witnessed its first industrial boom, beginning in the 1940s with the Reeves Rubber plant and Gregorian Copper. Camp Pendleton, which borders San Clemente to the south, expanded housing areas toward San Clemente, and after the 1950s surfing boom, San Clemente became the quiet home of a variety of surfing equipment manufacturers and businesses. The community prided itself on a welcoming, friendly atmosphere with little crime other than the occasional car speeding down El Camino Real.

The 1950s were a time of growth and pleasure. The train running along the coast of San Clemente brought visitors to the dance casino, which became a dinner theater in 1972, where young adults

would listen to music of the day. Some even had the pleasure of hearing Judy Garland sing.

In 1969, Pres. Richard Nixon bought the H. H. Cotton estate. Nixon called it "La Casa Pacifica," although the press later nicknamed it the "Western White House." It sits above one of the West Coast's premier surfing spots, Trestles, and just north of historic surfing beach San Onofre. During Nixon's tenure, world leaders such as Soviet premier Leonid Brezhnev, Mexican president Gustavo Diaz Ordaz, Japanese prime minister Eisaku Sato, U.S. secretary of state Henry Kissinger, and U.S. president Lyndon B. Johnson paid official visits to the Orange County-born president. Following his resignation, Nixon retired to San Clemente to write his memoirs, joined by his speechwriter Ken Khachigan and a dedicated Secret Service detail.

San Clemente is known as a premier surfing destination and is home to numerous surfing magazines, foundations, and museums. The city has a large concentration of surfboard shapers and manufacturers. Many world-renowned surfers were reared in San Clemente or took up long-term residence in town. San Clemente High School is well known as a leader in National Scholastic Surfing Association titles.

San Clemente also has had a long-standing tradition of community festivities, with annual events such as the Fiesta, the Ocean Festival, the Seafest, the Beach Concert Series, and the largest Woody car show in the state.

San Clemente opens its doors and hospitality to everyone, especially during the summer months. The city almost doubles in size during July and August. The historic downtown district and Avenida Del Mar gear up before Memorial Day for the visitors, both renting in the beach area and visiting by train. The trains make two additional daily stops in the summer just to accommodate the influx of tourists who want to spend a day in the sun in a quaint and tidy little beach town. Many visitors feel that San Clemente reminds them of small coastal towns in Europe where a visitor can walk from beach to restaurant to gift shop within a few yards. Indeed, Ole Hanson's dream has become a reality.

# One

# THE BEGINNING
## SELLING A VISION

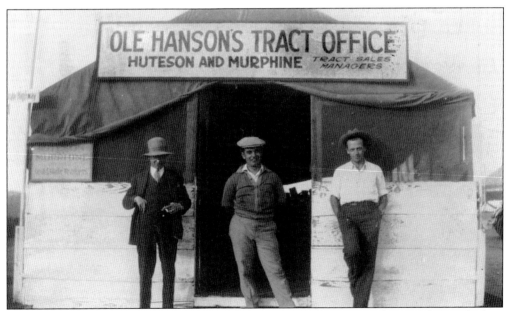

Scotty Watson, Thomas F. Muphine, and Trafford Huteson pose for a photograph outside their Tent Tract Office. On December 6, 1925, Ole Hanson began to share his vision with potential buyers, telling them, "We will build a pleasure pier, a golf course and a social club." Ole Hanson and Hamilton "Ham" Cotton purchased 2,000 acres from Adlai Goldschmidt and borrowed $1 million from Hellman Bank, which was bought by Mercantile Bank, and then by the Bank of Italy. A. P. Giannini of the Bank of Italy (later Bank of America) agreed to match any principal investments Ole Hanson and Hamilton Cotton raised. Ole Hanson and H. H. Cotton were joined by investors Cornelio Echinque, Frank Forster, William May Garland, H. G. Moulton, C. C. C. Tatum, and Ed Fowler. (Courtesy of Liz Hanson Kuhns.)

Horace Taylor, William Ayer, and Ole Hanson Jr. begin surveying the village's first 125 acres. Ole Hanson wanted his city to resemble a theater, using the land's natural bowl-shaped formations, with the ocean as the stage, the pier and bowl as the orchestra, and the homes and streets as the mezzanines and lodges. Every home would have an ocean view.

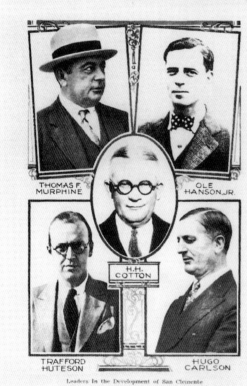

The city's first investors included Hamilton H. Cotton, pictured in the center. Pictured from upper left are founding members of the Ole Hanson Organization ("OHO") Thomas F. Muphine (the city's first mayor and a close friend of Ole Hanson), Ole Hanson Jr. (Ole Hanson's son and key sales representative), salesman Trafford Huteson, and Hugo Carlson. (Courtesy of Liz Hanson Kuhns.)

Traveling down Highway 101, the scenery was cattle and orange groves. Lloyd Hanson recalls his first visit to San Clemente. Ole Hanson turned onto a wagon trail soon to be called Avenida Del Mar, which took motorists to the ocean. However, cattle were still grazing in the area. Ole said, "Forster is going to herd them to San Onofre; that's the county line. You can tell; there's a trestle there." (Courtesy of Liz Hanson Kuhns.)

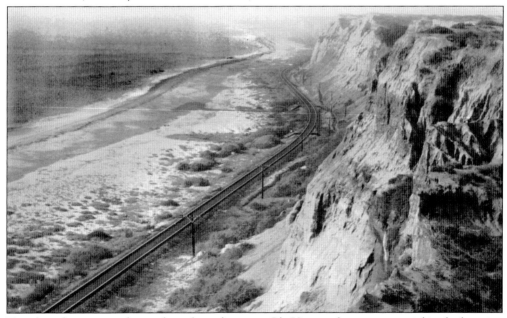

Traveling the train tracks winding along the coast, Ole Hanson first saw potential in the location for his vision of a Spanish Village. Later he would drive down Highway 101 toward San Diego past the Mission San Juan Capistrano and the Goldschmidt palisades. His vision of building a village of white stucco homes with red tile roofs grew steadily for five years until the opportunity to begin building his dream city presented itself. (Courtesy of Liz Hanson Kuhns.)

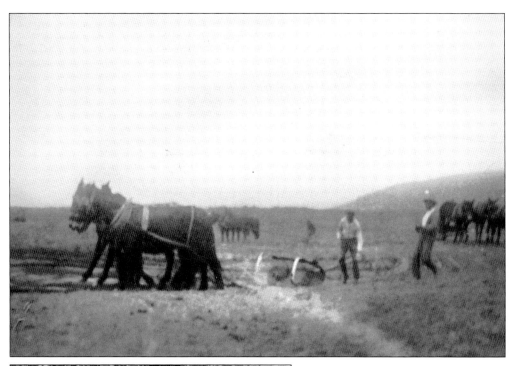

The mules are put to work on building San Clemente. An 8-foot-tall wooden post set on a corner of Highway 101, also known as historic El Camino Real, marked the corner of Avenida Del Mar. The only other main artery through the area was the Santa Fe Railroad. (Courtesy of Liz Hanson Kuhns.)

Thomas F. Murphine (left) and Ole Hanson stand together. The first official act of Thomas F. Murphine, San Clemente's first mayor, was to accept on behalf of the city a water system built by the Hanson and Cotton syndicate worth $500,000 and purchased by the city for $1.

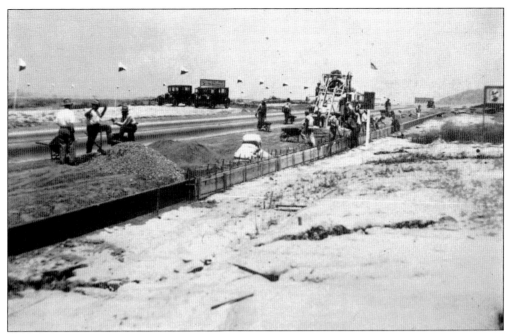

The work begins on the construction on South El Camino Real. Every street built had to meet with Ole Hanson's approval, which made progress slow but ensured accuracy to his vision. El Camino Real, also known as The King's Highway, was originally a footpath used by Spanish missionaries, connecting Spanish outposts and missions. (Courtesy of Liz Hanson Kuhns.)

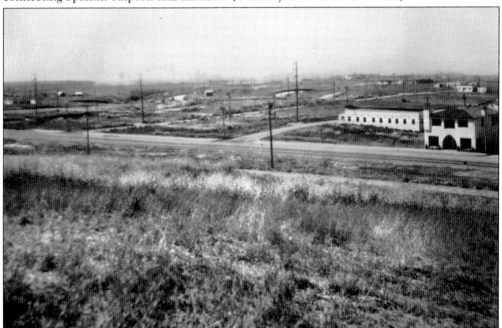

Along El Camino Real, one of the first buildings, the Hotel Granada, was originally built for the workmen. The original El Camino Real footpath became a roadway wide enough to accommodate horses and wagons and has become known as Highway U.S. 101, portions of I-5, Route 72, Route 82, and I-280. (Courtesy of Liz Hanson Kuhns.)

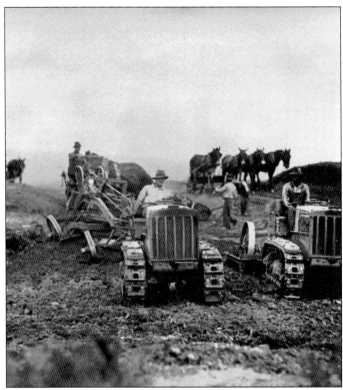

The use of tractors increased the speed of grading, although the mules were still an unbeatable resource due to the terrain. Hanson directed that each plot be delineated with white strings to visualize each detail and ensure the homes were placed optimally on each lot.

Seen below are the Beach Club, visible along the bottom of the photograph; the baseball diamond; San Clemente Plaza Park; the San Clemente Grammar School; and El Camino Real, curving south toward Del Mar, where Ole Hanson's Office and the Bartlett Building can be seen. (Courtesy of Liz Hanson Kuhns.)

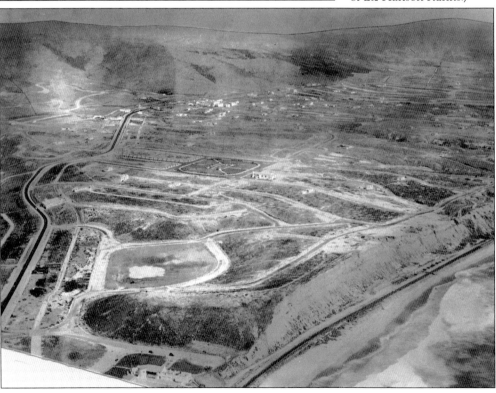

On the corner of El Camino and Del Mar, the construction begins on Ole Hanson's Office. Tents are set up in the area, soon to be the home of the Bartlett Building across Del Mar. Behind Ole Hanson's Office, a sales tent is set up where the San Clemente Hotel will soon be built. Almost completed, next to Ole Hanson's Office, is the first gas station in town.

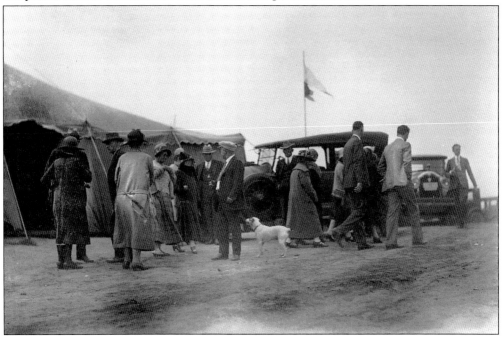

Ole Hanson is pictured here with town founders, representatives, and future residents. Hanson would walk over each lot with prospector buyers. He would advise each owner on the best location for construction to optimize their view of the ocean and enjoyment of its breezes. (Courtesy of Liz Hanson Kuhns.)

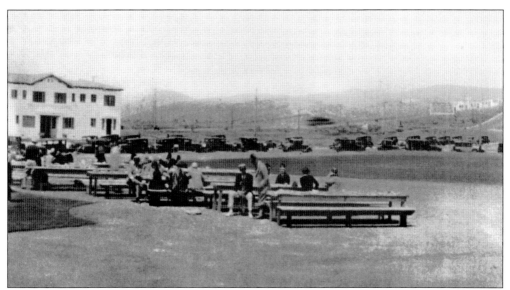

A group sits behind the Villa Del Mar Apartment buildings adjacent to the baseball field. Often the Shriners would have their meetings and events here. Many can be seen wearing their fezzes. (Courtesy of Liz Hanson Kuhns.)

In the foreground is the water reservoir, located in the center of town. After the building was demolished, Cabrillo street was built over the long and grand entrance staircase that led up to the water works. One of Mayor Murphine's first official acts was to formally accept, on behalf of the city, a $500,000 water system, with three levels of reservoirs serving every lot in the city. The water system was built for the city by founder Ole Hanson and the Hamilton Cotton syndicate. The city paid $1 for the system. (Courtesy of Liz Hanson Kuhns.)

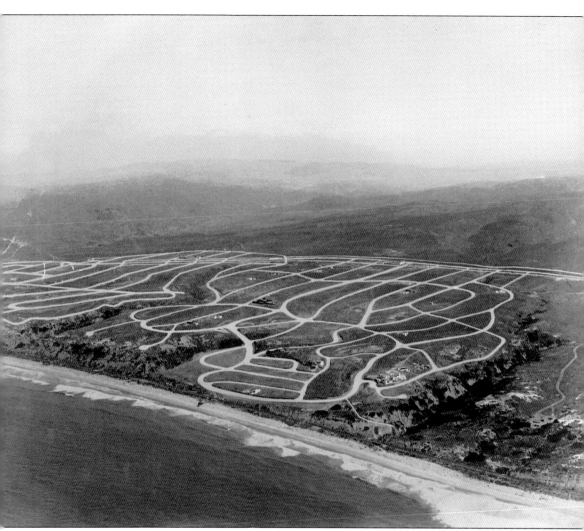

An aerial view shows Ole Hanson's roadways. Hanson insisted on creating roads that went with the contours of the landscape, rather than building roads in the popular, convenient, grid-like pattern. William Ayer, the city engineer, was tasked with building roads miles long that wound over hillside terrain. Seen in this image on the far right are a group of homes along the south ridge. These homes soon became known as Pasadena Colony, because so many people from Pasadena built their summer homes in that location. (Courtesy of Liz Hanson Kuhns.)

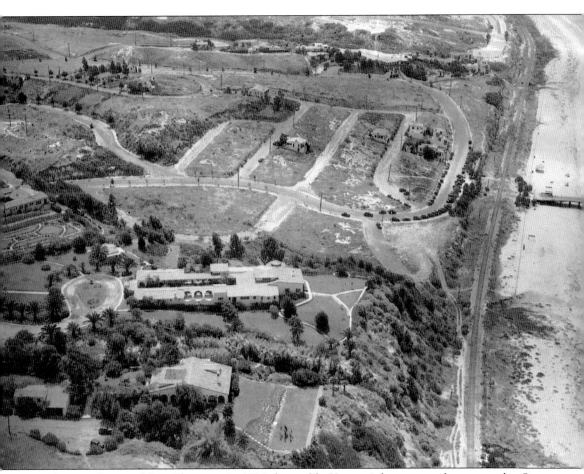

An aerial view of San Clemente in 1934 shows Ole Hanson's home, now known as the Casa Romantica. Below the Casa Romantica is Ole Jr.'s home, which was said to be quite grand inside. Southeast from Ole's home is the home of Oscar Easley, and later the Rasmussens, with its accompanying sunken garden and tennis courts.

Ole Hanson's dream is under construction. A sign advertises that the first service station is being built. The construction visible in this photograph is Ole Hanson's Office and the adjacent San Clemente Café. The exterior stairs can be seen alongside the building and the courtyard to the right of the stairs.

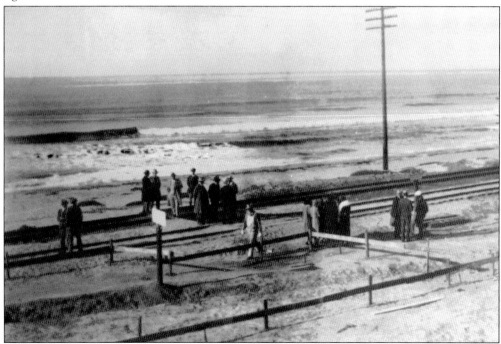

The Santa Fe Rail Line through San Clemente stopped here at the North Beach station, only one of two main routes through San Clemente. Ole Hanson and his team await the train's arrival to greet prospective property owners. (Courtesy of Liz Hanson Kuhns.)

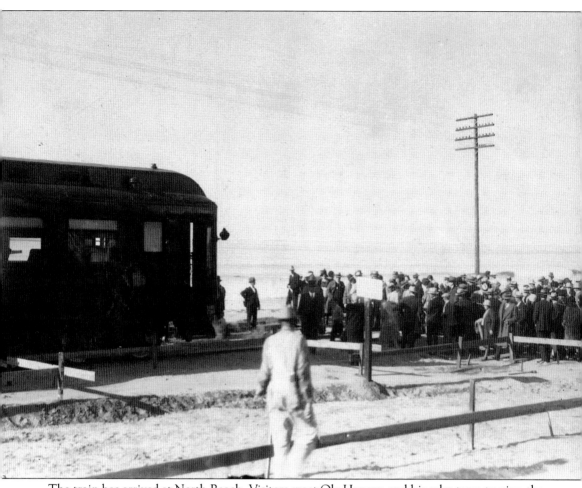

The train has arrived at North Beach. Visitors greet Ole Hanson and his sales team to view the property lots. H. H. Cotton's estate, which later became known as the Western White House, located next to the train line, was where Pres. Franklin Delano Roosevelt would stop the train at Cotton's estate to be lifted, in his chair, up into Cotton's gazebo for a game of cards. (Courtesy of Liz Hanson Kuhns.)

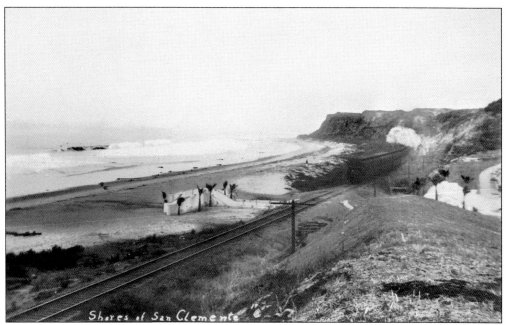

The bowl at the base of Avenida Del Mar and Avenue Victoria is shown here. The underpass and the pier have yet to be constructed. This postcard was sent to friends with the explanation that the sender "couldn't believe this is the beach where she would be swimming all summer!" (Courtesy of Lois Divel.)

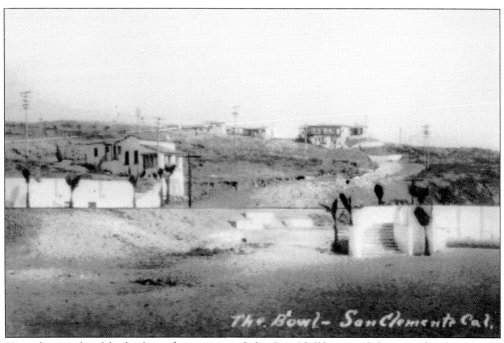

Here the pier bowl looks from the sea toward the Sea Cliff house. If this was the theater Ole Hanson dreamed about, with the ocean as the stage, these homes were in the orchestra. Some of the largest and most beautiful homes were built for the founders.

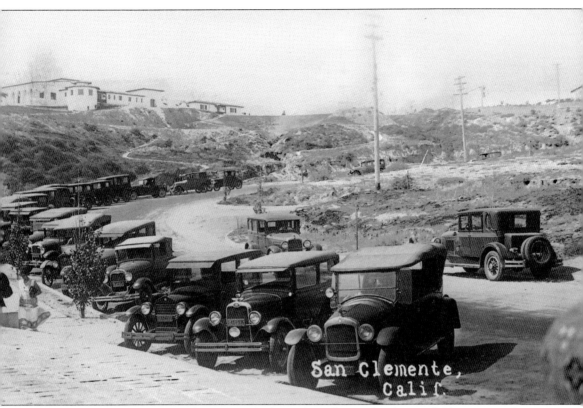

This image, taken on Avenida Victoria, looks up from the pier bowl toward Ole Hanson's home and the Oscar Easley house. Every car owner in town was asked to come to the bowl and park for a photography session. The automobiles pictured here include a 1914 or 1915 Ford, a 1915 Ford Model T, a 1932 Buick, a 1929 Ford Sport Coupe, a 1932 Chevrolet, a 1925 Reo, a 1925 Dodge, a 1927 Ford, a 1925 Buick, a 1927 Ford Model T, and a 1929 square-top pickup. The presence of modern "seal beam" headlights helps to date the photograph around 1932 or 1933. (Courtesy of Lois Divel.)

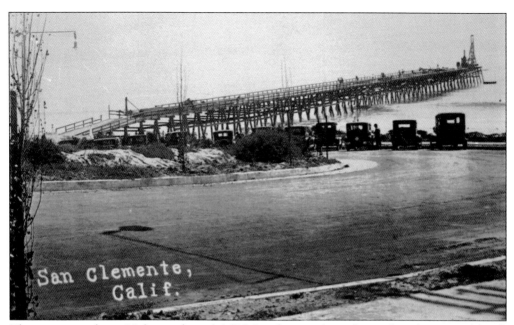

The pier started out 24 feet wide and 1,200 feet long and was located in the natural bowl, hidden to those traveling along Highway 101. It is only visible from the sea and beach. Even today, the pier is owned by the people of San Clemente. It was designed by the town's very own engineer, William Ayer.

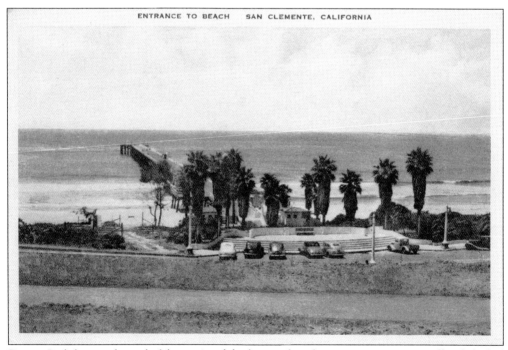

During Prohibition, the end of the pier's café had a trap door for rum runners to move illegal alcohol from small boats underneath the pier. The café and its trap door were destroyed in the hurricane of 1939. The pier was rebuilt with 77 more feet and a T-section, seen here, completed in 1940.

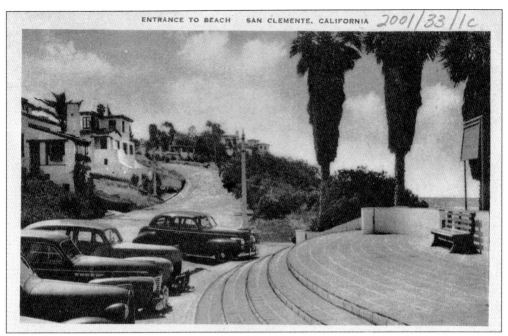

The Pier Bowl entrance looks southeast up Avenida Victoria. After 1940, the end of the pier included a hydraulic hoist and landing facility for boats. Boats were hoisted out of the water and pulled by small tractors and dollies into storage areas.

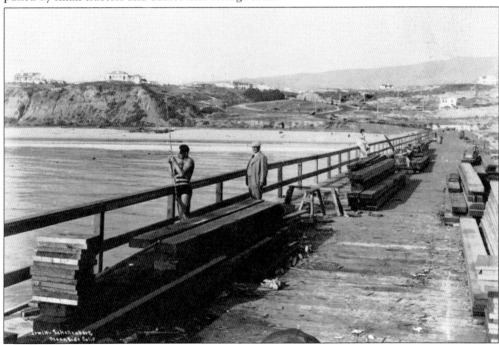

The citizens of San Clemente were so excited to use their pier that the city allowed the first 900 feet of the pier to be used before the entire 1,200 could be completed. From this view, Ole Hanson's house and other Hanson-built homes are visible. Most have since been demolished. (Courtesy of Liz Hanson Kuhns.)

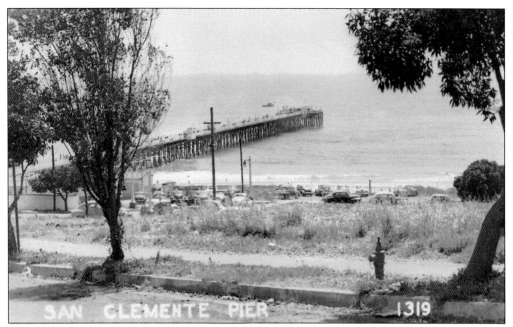

The San Clemente Pier is shown here populated with visitors and residents alike. An early sport fishing boat can be seen, possibly coming into the hydraulic landing system. (Courtesy of Lois Divel.)

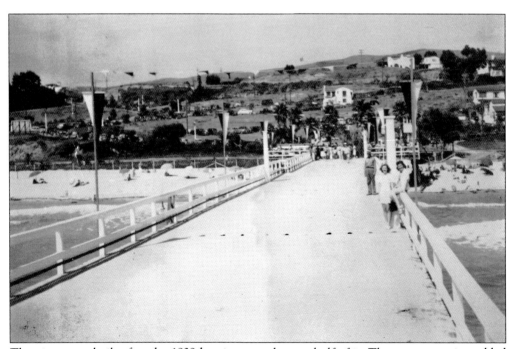

The pier was rebuilt after the 1939 hurricane took away half of it. The reconstruction added 275 new pilings and changed the pier into a T shape. In 1983, a second damaging storm caused another collapse of the pier, this time leaving intact the middle portion and destroying both ends. (Courtesy of Liz Hanson Kuhns.)

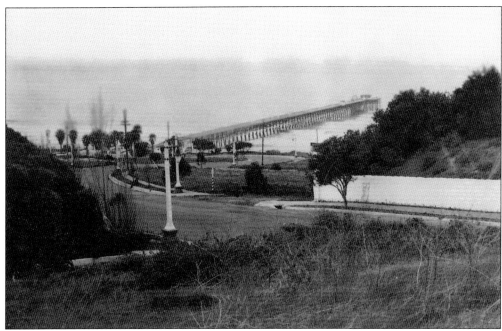

Here is a view of the pier from Avenida Victoria. Also visible at the end of the pier is Stearn's Café. On the right of the photograph is the retaining wall for the Rasmussen house and garden, a favorite "walking wall" for the children running down to the beach.

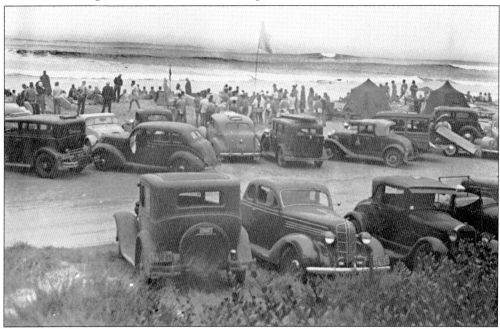

This is a view of surfing in the early days, around the 1930s, possibly at San Onofre or North Beach. These mainland founding fathers of surfing used hollow paddleboards and hot curl boards seen here on top of cars on the beach and under arms. One convertible visible in the photograph appears to be that of Eugene Field "Bunny" Hanson's, one of Ole Hanson's younger sons. His yellow convertible was well known around town.

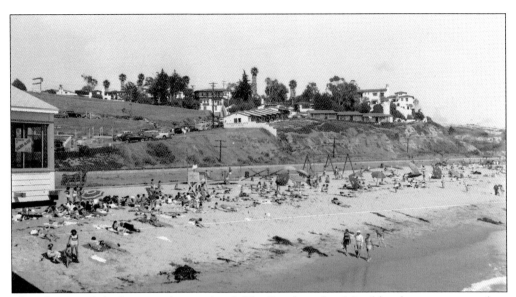

This photograph looks up at the pier bowl. The Beachcomber Motel has been constructed on the ridge, and the Boat Club built by Jack Rettke can be seen on the left. The photograph may have been taken around 1946. (Courtesy of Lois Divel.)

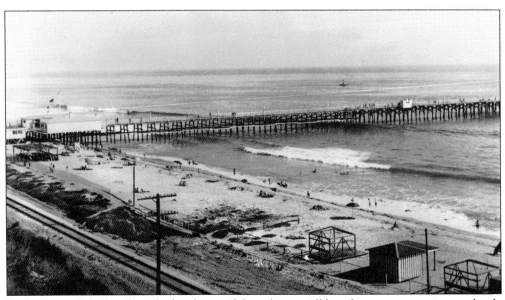

In this view of the beach at the bowl, one of the cabanas still has the canvas covering used only in summer, also known as "sun-tan cabanas." During the winter, the cabanas sat on the beach in skeletal form. The Boat Club buildings can be seen on either side of the front of the pier. (Courtesy of Lois Divel.)

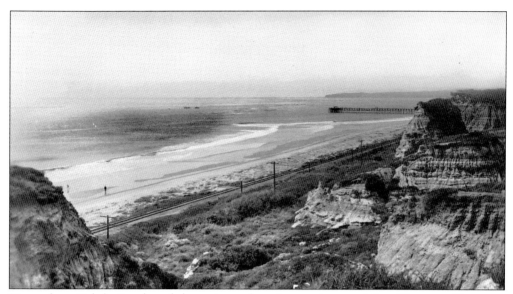

Pictured are Calafia Beach and the train tracks going north toward San Clemente. For many years the American Automobile Association Club books listed San Clemente as famous for its sandstone rock formations. (Courtesy of Lois Divel.)

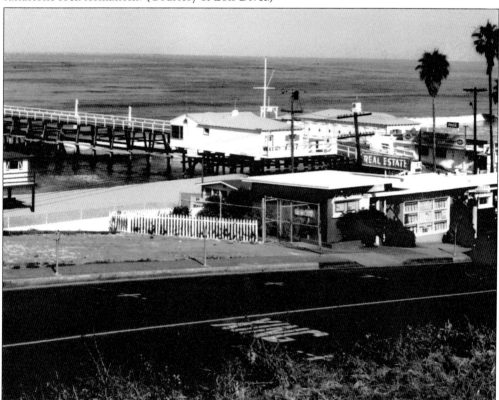

On the shore end of the pier were the San Clemente Boat Club and storage space for boats. Boats would be lifted by hydraulics from the ocean and pulled into their storage locations in each building. Across the train tracks are a real estate office and the tackle shop.

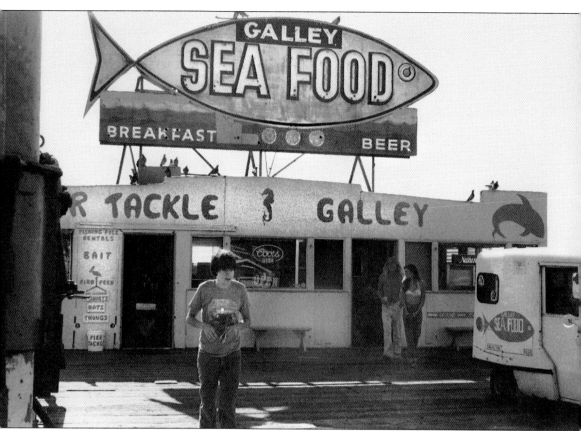

By 1960, the tackle shop and galley owned by Bud Gable was located at the end of the pier. The neon sign of the fish flickered as a beacon seen from the shore. Fishing was big business in San Clemente. Concerning construction of the pier, Lloyd Hanson recalls, "In 1925 Dad was in Capistrano and saw two men with a sack of fish. 'Where did you get the fish?' he inquired. 'We fished near the kelp beds, near Seal Rock . . . There's a natural bowl that goes right to the beach.' Dad [said,] 'That's where we'll build the pier!'"

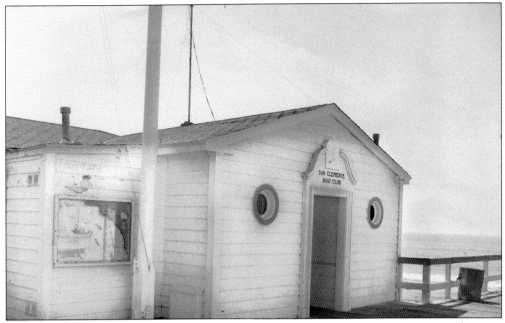

The San Clemente Boat Club sits at the shore end of the pier in the 1970s. In 1947 San Clemente and Dana Point, then unincorporated, began talks on the joint uses of the San Clemente-Dana Point Harbor. The boat club and other boating ventures moved to Dana Point after the construction of the Dana Point harbor and the dedication in 1971.

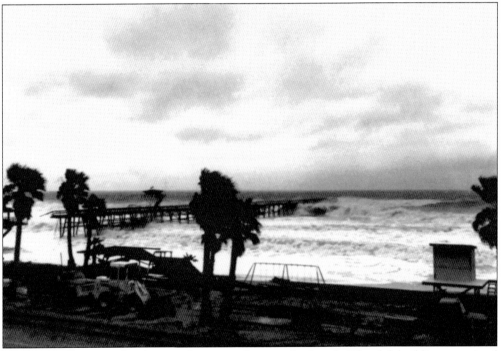

In 1983, another storm hit the pier, this time taking out both ends. The club buildings remained standing, and the middle section of the pier was all that was left. The Gallery restaurant and Pier and Tackle shop at the end of the pier succumbed to the 35-foot waves.

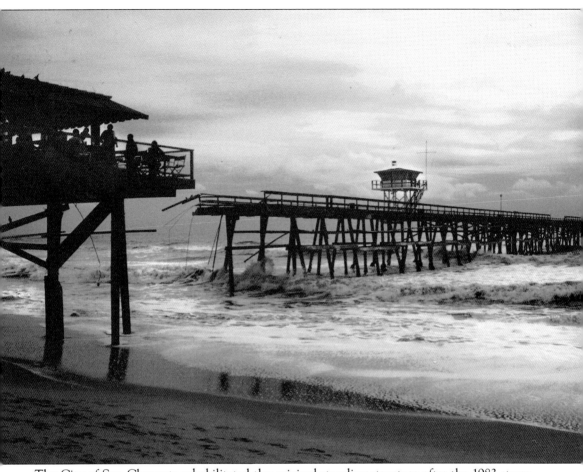

The City of San Clemente rehabilitated the original standing structure after the 1983 storm with the help of Save Our Pier, raising $90,000, and $1 million from the Federal Emergency Management Agency. Drift pins were replaced with steel pilings, and the destroyed portions were rebuilt. (Courtesy of Pat Bouman.)

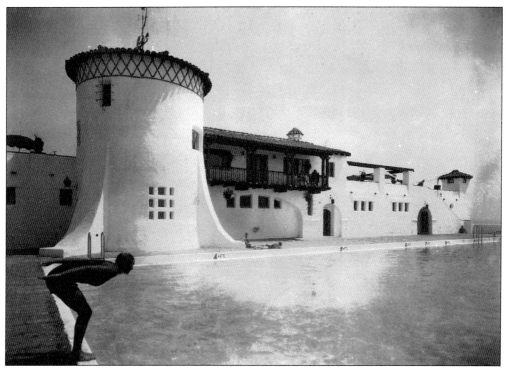

The Ole Hanson Beach Club, one of the first amenities built, has also been known as the "plunge," the public pool, or the community pool. Ole Hanson's Beach Club opened in May 1928, designed by Virgil D. Westbrook. Westbrook's designs called for a saltwater plunge, dressing rooms, lockers, lounges, and terrace roof gardens.

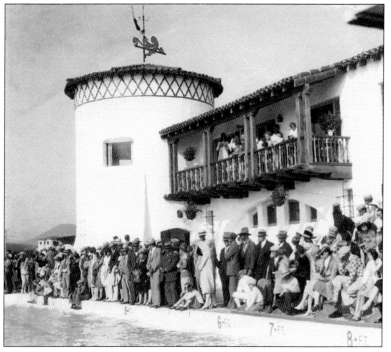

The trials for the 1932 Olympics were held at the Beach Club, which featured a near-Olympic-sized pool. The "plunge" was 45 feet wide and 105 feet long, with depths of 3 feet to 9.5 feet, and a capacity to hold 196,000 gallons.

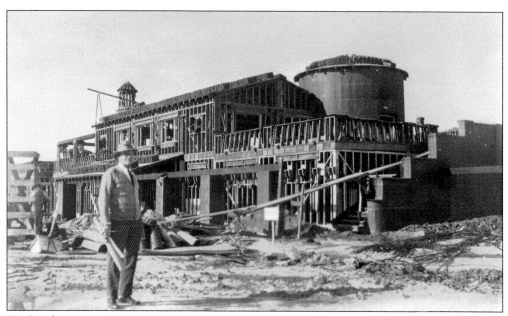

Workers here are erecting the frame for the Ole Hanson Beach Club. One of many gifts built at Ole Hanson's expense and donated to the residents of the city, the beach club held Olympic trials in 1932. Hollywood star Johnny Weissmuller (of *Tarzan* fame) was one of the celebrated entrants.

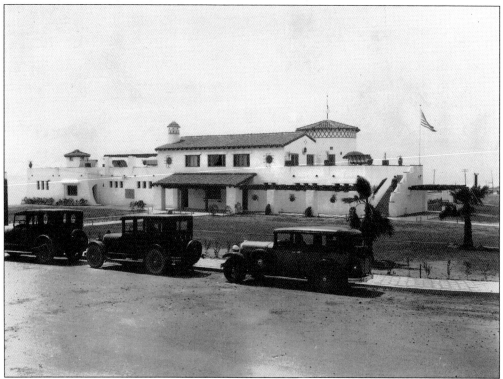

This photograph shows the completed Ole Hanson Beach Club on opening day. The open roof terraces on either side of the roof are visible from this north-facing view. Note the newly planted palms and ferns.

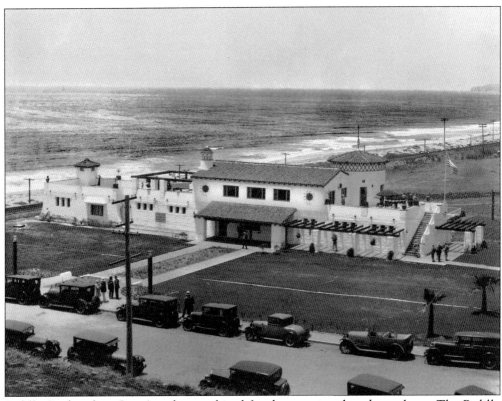

Padilla Studios from Los Angeles was hired for the opening day photo shoot. The Padilla photographer caught patrons arriving to experience the opening day of the Ole Hanson Beach Club. Model Ts and Model As line the cul-de-sac in front of the Beach Club.

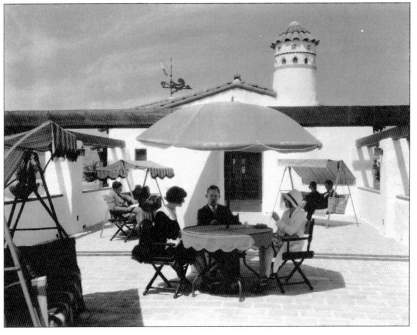

Patrons enjoy the breeze on the roof terrace of the Ole Hanson Beach Club. Each building was outfitted with a different weather vane. The Beach Club's weather vane depicted a diver and ocean waves. (Courtesy of the San Clemente Historical Society.)

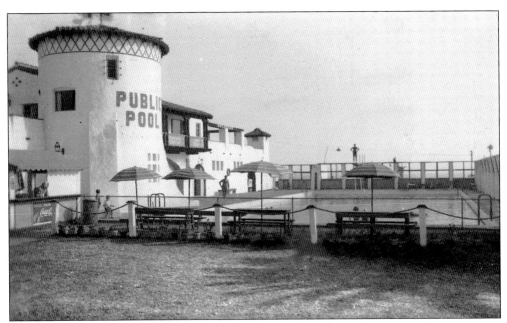

In the early 1940s, the Ole Hanson Beach Club added a new glass wall in one of the attempts to keep the wind out. The building was now labeled "Public Pool." Frequently divers and swimmers, such as Buster Crabbe and Duke Kahanamoku, would perform for the San Clemente crowds. The San Clemente Historical Society was a lead participant in the drive to prevent demolition of the Ole Hanson Beach Club when it fell into disrepair in the 1970s. (Courtesy of Lois Divel.)

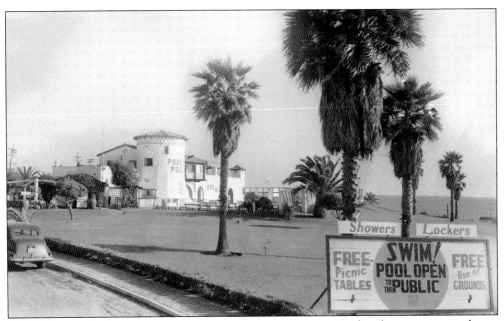

The club provided lockers and picnic tables. A restaurant serving hamburgers was nearby, so visitors and residents alike could make a day out of it. The San Clemente Historical Society donated the colorful ornamental tiles that face the steps leading to the upper level today. (Courtesy of Lois Divel.)

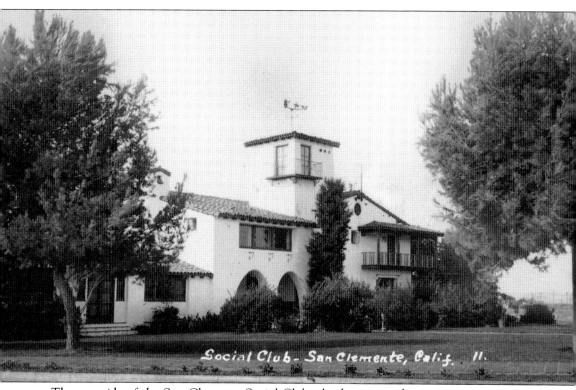

The east side of the San Clemente Social Club, also known as the community center and historically as The Clubhouse, stands at the corner of Avenida Del Mar and Calle Seville. One of the first buildings erected, the social club has been the site for numerous events since completed in January 1927. The club was fabulously furnished, yet after founder Ole Hanson paid for the entire project, he sold it to the city for $1. Of the Saturday night dances held at the clubhouse, the local newspaper reported, "The music consisting of four pieces is snappy and up-to-date and anyone who can use their feet at all can hardly refrain from taking the center of the floor and doing the dipsy-doodle the same as the younger members present." (Courtesy of Lois Divel.)

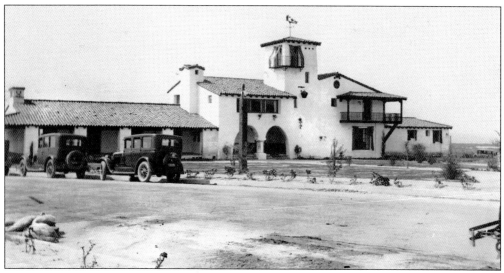

The social club originally cost over $100,000 to construct. Lloyd Hanson recalled that during Prohibition bootleg liquor was placed in the palm trees, so that guests could go outside for a cigarette and a swig. (Courtesy of Lois Divel.)

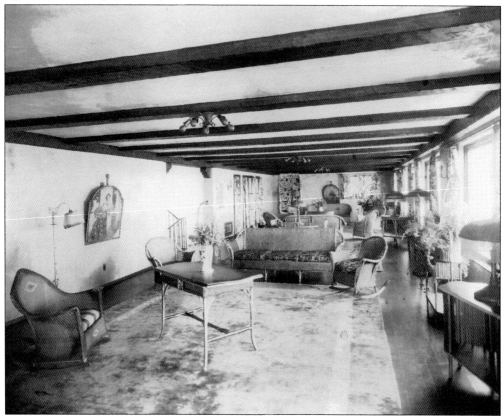

This interior room upstairs in the clubhouse is decorated with Spanish Revival furniture and woven Mexican rugs. The room was used for club meetings and as a ladies lounge. It was part of the building lost in the fire in 1970. (Courtesy of Lois Divel.)

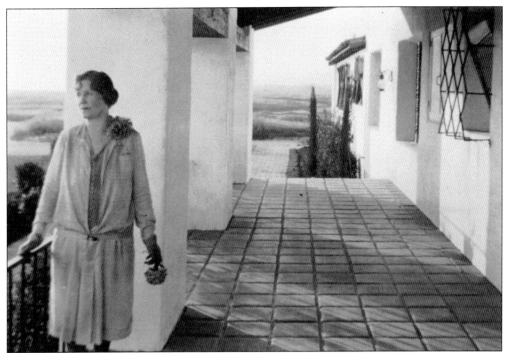

The west veranda of the San Clemente Social Club used to be the main entrance. This photograph of a woman on the veranda was taken by Padilla Studios and dates from 1927, shortly after the building's completion. For many years, the tower was the home of the caretaker, Mrs. Elterman (not pictured). (Courtesy of Liz Hanson Kuhns.)

After the fire of 1970, only the Ole Hanson Room remained intact, and the rest of the building had to be reconstructed. Afterwards, the Don Quixote weather vane, which had been salvaged, was finally returned to its home and relocated on top of the new building. While the "Ole Hanson room" survived the fire, the reconstructed side of the structure was dubbed "the pillbox" by residents who felt the reconstruction did no justice to the original architecture.

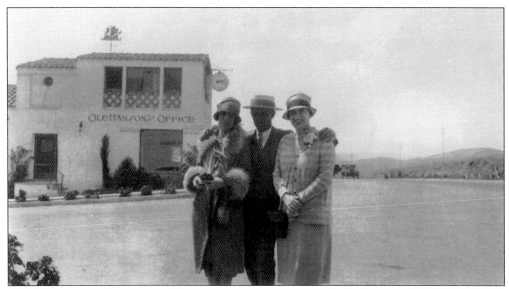

The first structures built in San Clemente were a gas station and Ole Hanson's Office, also known as the Administration Building. The office, seen here in the background behind some unidentified visitors, was located on the corner of Avenida Del Mar and El Camino Real and contained a central courtyard. A café was added in 1931. (Courtesy of Liz Hanson Kuhns.)

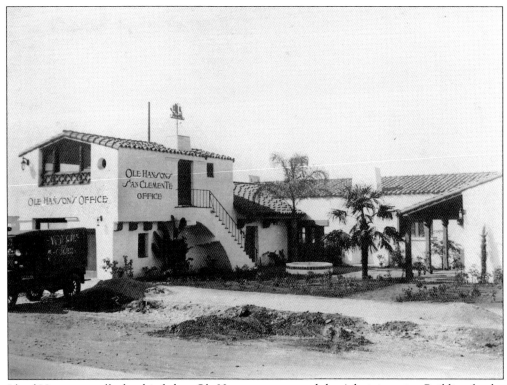

Lloyd Hanson recalls that his father, Ole Hanson, never used the Administration Building for the first five to six years. Most of the deals were made on the lots or in the car, and the paperwork was taken care of in the Los Angeles office.

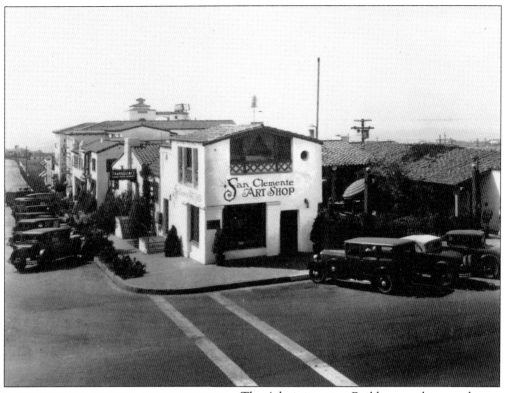

The Administration Building was later used as an art supply store operated by Ole Hanson's daughter Doris in 1927. The Great Depression brought construction in San Clemente to a halt in 1931. San Clemente had been on the map for only five years and had seen the rapid construction of over 500 structures. Most of its first 1,000 homeowners had been relatively wealthy Los Angelinos, but the economic collapse forced them to walk away from their second homes in San Clemente.

The left wing of the Administration Building changed owners over the years, serving as a bank, an art shop, a travel agency, and an ice cream store. The right wing of the building was always a restaurant. An additional building was constructed later in the courtyard between the two wings. (Courtesy of Lois Divel.)

# Two

# THE OUTDOORS
## GOLFING, HORSES, FISHING, AND SURFING

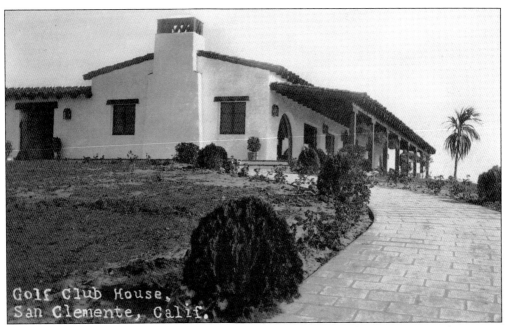

The first San Clemente Golf Course Clubhouse was erected in 1930 near the corner of Avenida Magdalena and South El Camino Real and was designed by noted architect William Bell, who designed the course to follow the contour of the hillsides. The large Spanish Colonial clubhouse housed the Green Acres restaurant, which specialized in fried chicken and was operated by the George Rettke family. (Courtesy of Lois Divel.)

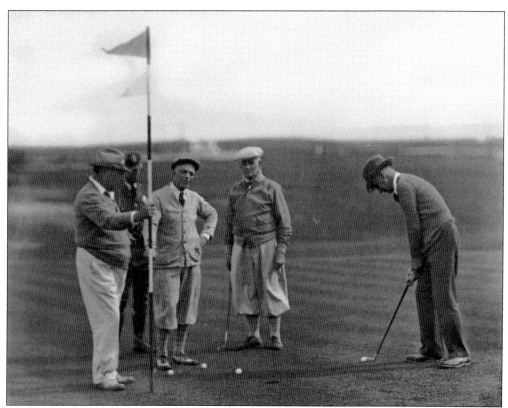

A golf course can be a place to plan a city. Seen here from left to right are Tom Murphine, the first mayor; Harry Comber, a San Clemente police officer; Long Beach councilman Frank Church; San Clemente councilman and sweet shop owner Bert Latham; and Long Beach mayor Oscar Hegee. (Courtesy of Liz Hanson Kuhns.)

In addition to the club house, a pro shop and maintenance building were constructed. The nine-hole course was expanded into an 18-hole course and given to the City of San Clemente. It was said to be the only all-grass course between La Jolla and Long Beach. The 1950s clubhouse building was later converted into a Catholic church and then a Mormon temple before being demolished. (Courtesy of Liz Hanson Kuhns.)

The old Spanish Colonial golf clubhouse was torn down in the early 1970s when the city sold the property, and a condominium complex was built on its site. The golf course added nine holes and a new clubhouse with Polynesian architecture, designed by local architect Chris Abel. Ironically, that clubhouse was torn down and replaced by an even larger Spanish Colonial clubhouse in November 2007. (Courtesy of Lois Divel.)

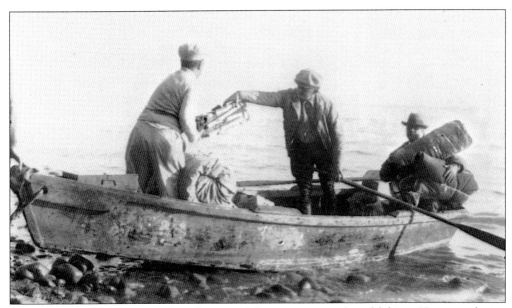

This boat coming ashore may have been used for an innocent day of fishing. However, during Prohibition, many small boats would travel to San Clemente, rum-running or bootlegging alcohol. The rumrunners would deliver their products to San Clemente via small boats and maneuver beneath the end of the pier where a trap door was built into the floor of the café. Bootleggers would hoist their wares into the café unseen.

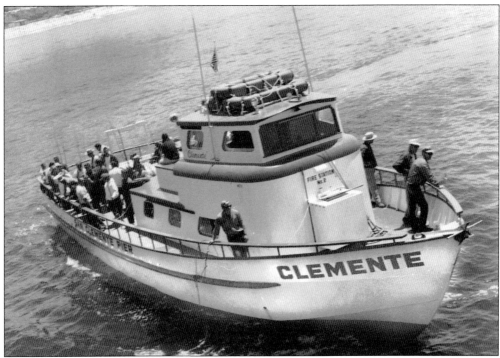

The *Clemente* was John Carighton's boat, one of the more popular fishing boats in San Clemente before the City of Dana Point removed the local natural reef and constructed the Dana Point Harbor shared by San Clemente's fishing and boating businesses.

Alfonso Jimenez, Richard Smith, and Adolph Jimenez pose by a large catch on the San Clemente Pier. Richard Smith was the son of Leo Smith, a former mayor of San Clemente. Sportfishing boats were able to dock at the end of the pier, and children with fishcarts made pocket money by helping to haul the catch. (Courtesy of Lois Divel.)

*Fishing Aplenty at San Clemente* was the logo for San Clemente Sport Fishing Inc. The advertisement was true. At one time, there was an abundant supply of fish. The San Clemente Yacht Club was founded with 50 charter members, and soon 24 yachts were anchored nearby.

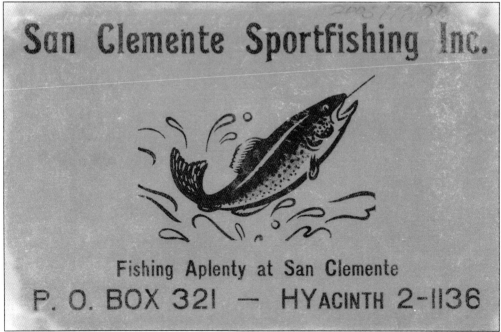

An advertisement for Don Hansen's San Clemente Sport Fishing Inc. With the construction of the 1,200-foot-long San Clemente pier in 1928, sportfishing became a huge pastime for residents and visitors alike. Lobster populated the area around the pier, and abalone was plentiful in the small reef off Mariposa Point. For decades, anglers pulled a million tons of fish per year from local waters. Tourists could even fish from a special barge. San Clemente's sportfishing days were over with construction of the Dana Point Harbor in 1971.

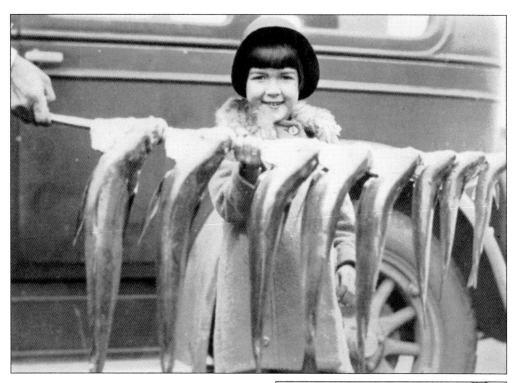

The little girl posing with the catch of the day (above) was just walking by when the photographer asked her to stand by this large catch. (Courtesy of Liz Hanson Kuhns.)

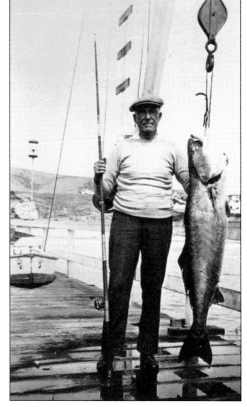

Numerous and large fish were frequently found in San Clemente waters. It is said even a "monster" was found off the shore. In 1916, a 68-ton, 55-foot creature was taken from the sea between San Clemente and Catalina Islands. It became known as the "Clemente Monster" but was mostly likely a rare species of whale.

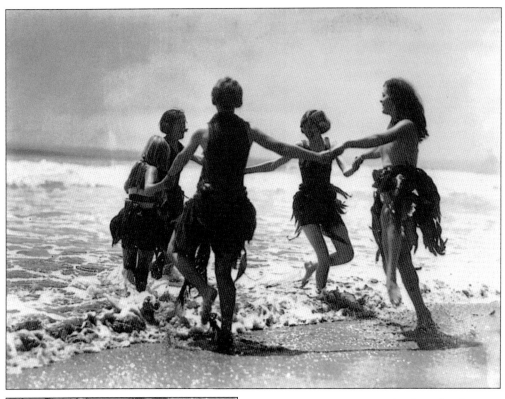

Marge Hanson is seen on the far right above, dancing in a sea kelp skirt. The sea and the mountain trails offered many creative backdrops for residents. In winter, children could gather around a Christmas tree placed on the beach. (Courtesy of Liz Hanson Kuhns.)

For many years, San Clemente was known for its sandstone cliff formations south of town. There are no other like them anywhere in the world. The sandstone canyons were created by the Christianitos earthquake and shaped by the sea.

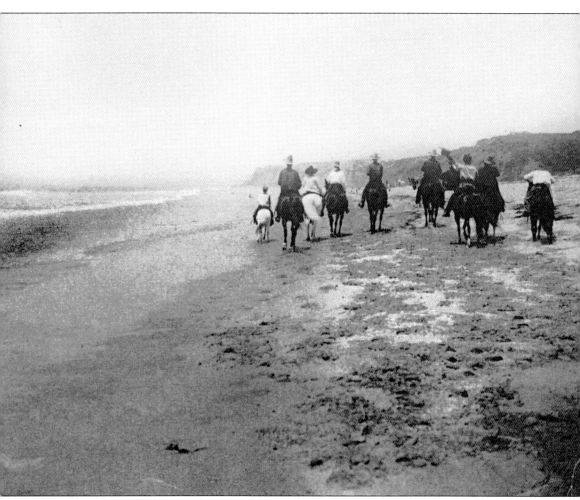

The San Clemente Riding Academy met regularly early in the morning in front of Ole Hanson's Office for their ride along the bridle trails and beach available to the residents. Many residents were attracted to San Clemente because of its community stables. Ole Hanson even housed his famous Thoroughbred stallion, Elector, and his internationally famous five-gaited saddle horse, Marjorie Rex, at the stables. (Courtesy of Liz Hanson Kuhns.)

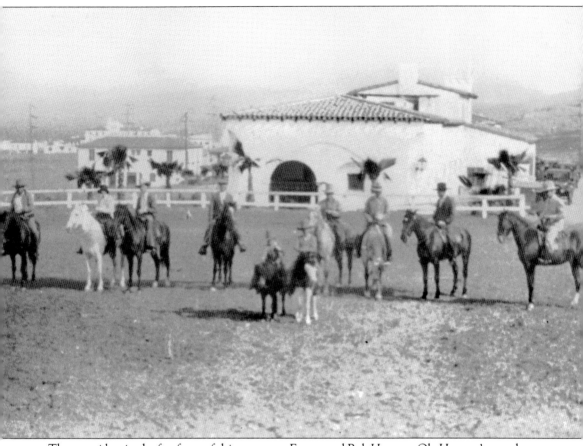

The two riders in the forefront of this group are Emery and Bob Hanson, Ole Hanson's grandsons. Ted Hanson, Ole Hanson's son, became a professional rodeo rider. "Grandma" Hanson is on the white horse flanked on her left by her husband, Ole Hanson Jr. Above the couple is the Divel Mortuary Building at the corner of El Camino Real and Trafalgar Lane. With little to obstruct the view then, barely visible in the far distance above the Divel building is the top portion of the Hotel San Clemente. Equestrian trails covered the city in the early days but have now been converted to street medians. (Courtesy of Liz Hanson Kuhns.)

A rider poses on The King's Highway, also known as El Camino Real, and in front of the San Clemente Riding Academy. The academy housed approximately six Kentucky saddle horses and a number of cow ponies. Ole Hanson, Ole Hanson Jr., and Hamilton H. Cotton all built their own stables near their homes. (Courtesy of Liz Hanson Kuhns.)

The interior of what appears to be either Ole Jr.'s stables or the San Clemente Riding Academy. The riding academy building was later converted into a hospital: each of the horse stalls became rooms with high ceilings and space large enough to fit three people comfortably. The hospital was known as "the hotel for sick people." (Courtesy of Liz Hanson Kuhns.)

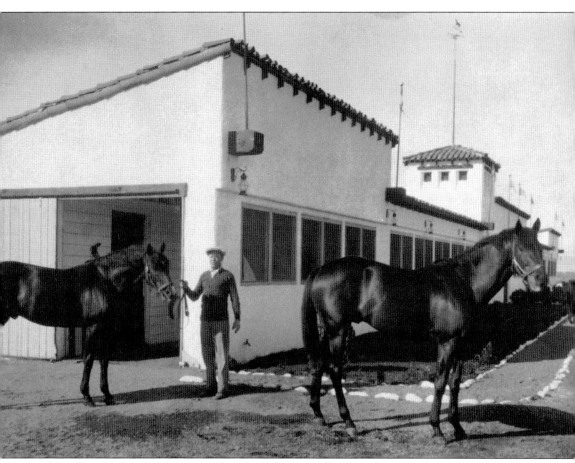

Hamilton H. Cotton's horse ranch and stables was called Rancho La Brea. In 1929, Rancho La Brea held over 21 Thoroughbreds. Hamilton Cotton's horses were some of the finest and ran at the Tijuana and Arlington Heights Chicago racetracks. In addition to Hamilton Cotton's private horses, some of the stables were occupied by racing stock owned by the president of the Elgin Watch Company and the owner of Fischer Automobile Body Works.

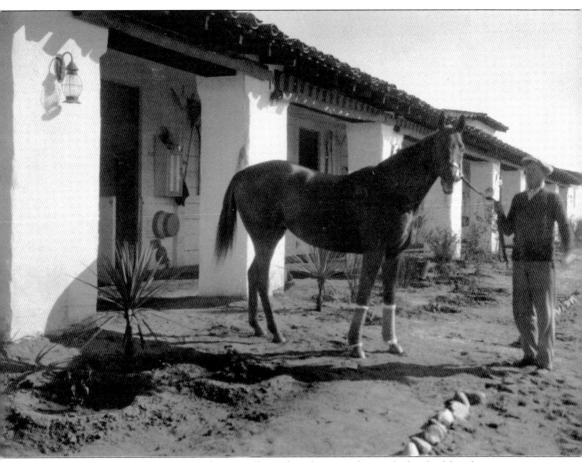

Hamilton Cotton built his stables, horse stalls, and oval racetrack even before building his vacation home, which he named Casa Tres Vistas on the 100-acre lot at the south end of San Clemente. In 1943, 62 acres of the estate were purchased by J. J. Elmore, a Thoroughbred breeder from Brawley, who called his horse farm Rancho San Clemente. It would become the largest single breeding farm in California with his famous horses Poona I, II, and III, among others, which ran at the Santa Anita, Hollywood Park, and Del Mar racetracks for years. (Courtesy of Liz Hanson Kuhns.)

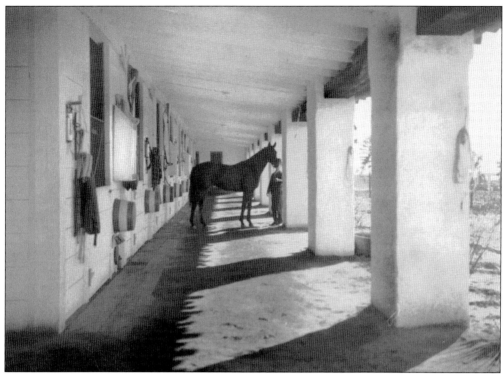

Hamilton Cotton's and later J. J. Elmore's property was sold in the early 1960s for a private residential development called Cyprus Shores. The beautiful Spanish Colonial stables would eventually become a clubhouse for the gated community's homeowners. (Courtesy of Liz Hanson Kuhns.)

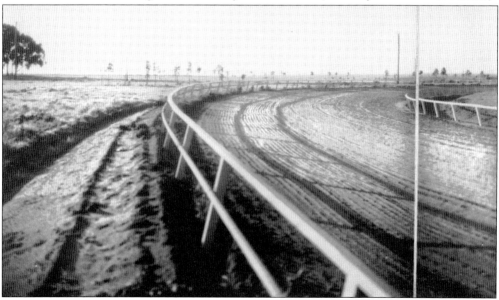

The oval track at the Cotton horse ranch, Rancho La Brea, was the location of a 1935 "On with Roosevelt" fund-raiser and rally. At the "Great Democratic Round Up," guests were treated to a barbecue and athletic events. Movie stars were on hand, and some 24 steeds appeared in a horse demonstration. (Courtesy of Liz Hanson Kuhns.)

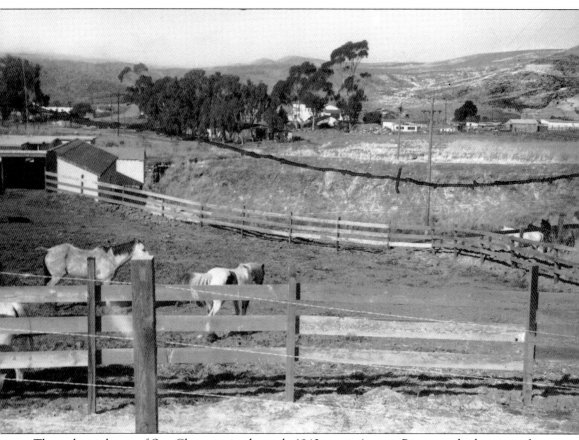
The industrial area of San Clemente in the early 1940s, near Avenue Pico, was the location of Reeves Ranch, owners of one of San Clemente's first industry Reeves Rubber, the San Clemente Dairy, and a furniture factory. (Courtesy of Bob Carrick.)

The San Clemente Industrial District covered 4 acres in the northeast end of town and operated there from the town's incorporation onward. One industry was the San Clemente Tile Company, who made all the tile required by San Clemente's building ordinances. Roof tiles were made the traditional way, shaped over a thigh before placing them to dry. (Courtesy of Bob Carrick.)

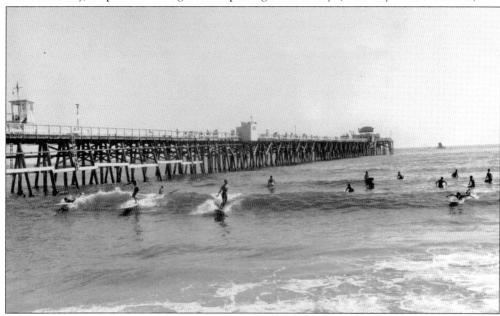

In the 1960s, with year-round waves and near-perfect weather, San Clemente was a great location for surfing, offering numerous sought-after surfing spots such as Trestles, North Gate, State Park, Lost Winds, Riviera, The Hole, Beach House, T-Street, The Pier, Linda Lane, 204, North Beach, and Poche.

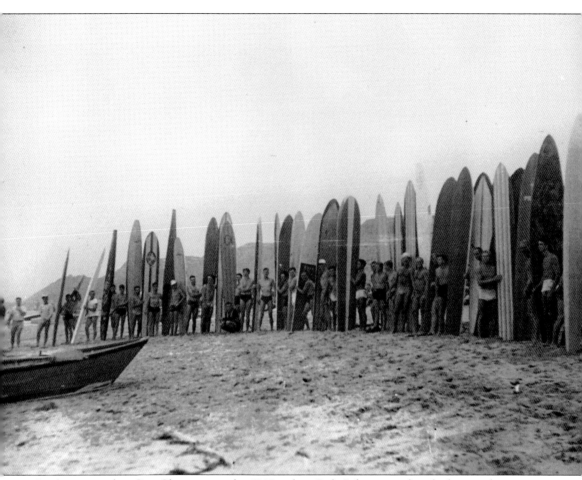

Surfing arrived in San Clemente in the 1930s when Bob Sides wanted to find a new location after Corona Del Mar, according to E. J. Oshier in *Living The Life*. At the time, there were fewer than 50 surfers on the entire U.S. mainland. Early San Onofre surfers included Lorrin Harrison, E. J. Oshier, Barney Wilkes, Dexter Woods, Vincent Lindberg, Charles Butler, Carol Bertolet, Benny Merrill, Frenchy Jahan, Dutchy Lenkeit, Joe Parsons, Davy Tompkins, George Blye, George Brignell. Ned Leutzinger, Lucien Knight, Winfred Harrison, Ethel Harrison, George Minor, Hubert Howe, Glen Bishop, Orly Minor, and George "Peanuts" Larson, some of whom may be present in this early photograph.

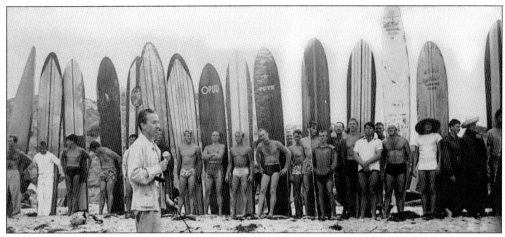

This image may have been taken by Dexter Wood, who photographed the 1938 San Onofre Surfing Team during the first surfing championship ever held on the mainland. By the 1960s, the surfing business boomed in San Clemente. Velzy Surfboards, on 1315 North El Camino Real, stated that they were the world's largest manufacturer of surfboards.

Loren Harrison Sr. was an early board builder in the late 1930s. In *Living the Life*, E. J. Oshier writes, "The first time we went there, they were making a Hollywood movie. They had built this big palm thatch house right on the beach. We slept in it the first night we stayed there. This was about 1933 or 1934."

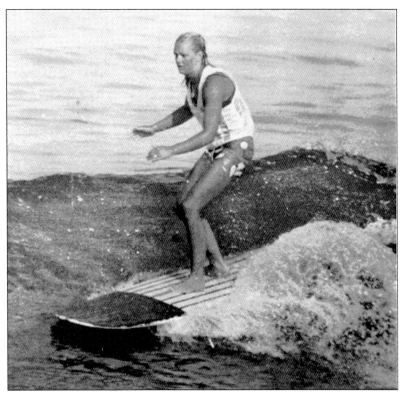

Joyce Hoffman was the Surfing Champion from San Clemente High School. She won the women's world title in 1965 and 1966 and in 1968 became the first woman to surf the Pipeline in Hawaii. In an interview with *Sports Illustrated* (October 18, 1965), she said, "After eight hours you can't move, [but] you have to do it. That's all there is to it." (Associated Press Wire Photo.)

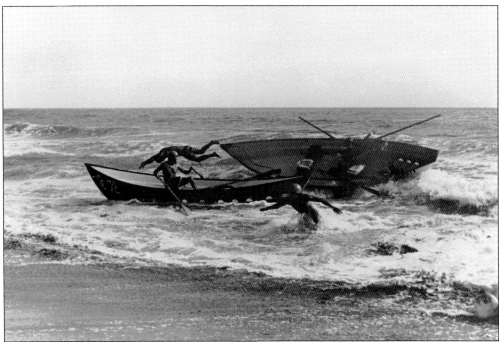

The Dory Boat Races have been a part of the Ocean Festival in San Clemente since the late 1970s. Usually there are about 10 dory boats per race, and anything can happen. It has been a test for the toughest lifeguards between Orange County and Los Angeles.

Taken from the Pier Bowl in 1930, this photograph looks toward the Bartow home, which can be seen on the bluff, and the Vista de las Olas, also called Sea Cliff. Once a symbol of San Clemente, the Bartow home was illegally bulldozed in the middle of the night in 1972. The demolition of the home caused so much grief that the San Clemente Historical Society was established to end the destruction that had already taken over 500 historic buildings. (Courtesy of Liz Hanson Kuhns.)

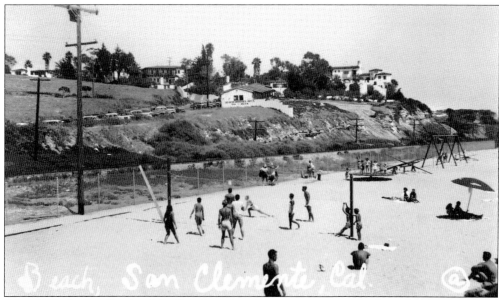

After 1950, the Pier Bowl and the Beachcomber Apartments are visible along the bluff below the Bartow house. The Beachcomber Apartments were constructed in the late 1940s. When, almost 50 years later, the building was slated for demolition, public outcry kept the historic structure intact. (Courtesy of Lois Divel.)

# Three

# THE COMMUNITY
## FAMILY AND FRIENDS

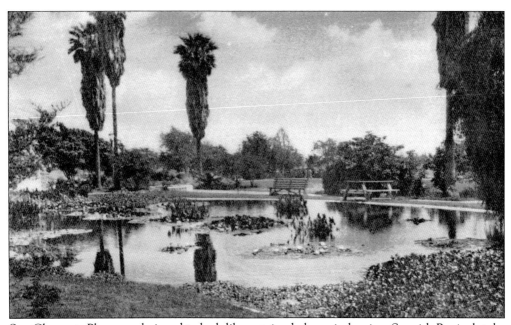

San Clemente Plaza was designed to look like a stained-glass window in a Spanish Revival style. It was three-eighths of a mile long and featured red tile sidewalks, palm trees, gardens, and a lake with black and white swans.

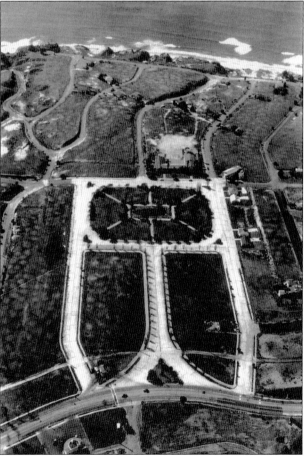

San Clemente Plaza, now known as Max Berg Plaza, was given to the citizens of San Clemente as a place to contemplate and wander. The town's first church and school, known as San Clemente Grammar School and later as Las Palmas Elementary, stood at its edges before being demolished in the 1970s and reconstructed in a different style.

In this aerial view of San Clemente Plaza Park, the stained-glass-window design is apparent. The surf can be seen in the distance. The new Reeves Rubber homes are seen on the right, the first homes built after the Spanish Revival–style construction restrictions were lifted. Visible are the Episcopal church (the first church built in San Clemente) and the San Clemente Grammar School, and along the bottom of the photograph is a drive-through restaurant. (Courtesy of Lois Divel.)

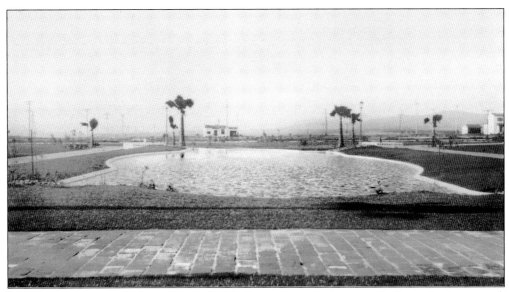

The Plaza Park pond, newly constructed with the red Spanish tile sidewalk, lies in the foreground. Newly planted trees are in the background.

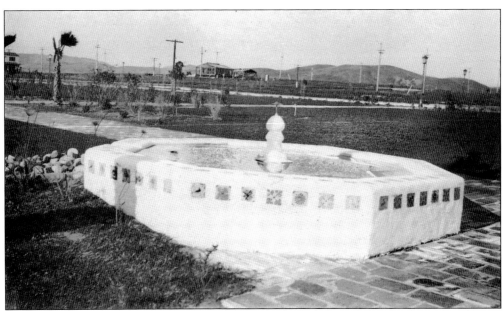

Fountains accent each corner of the San Clemente Plaza Park, now known as Max Berg Plaza. Max Berg came to San Clemente via Camp Pendleton and World War II. Max Berg was a comedian in Lt. Bob Crosby's traveling show; however, most remember him as the longtime city clerk with a humble personality and infectious smile. On his retirement, he was honored with the naming of the park.

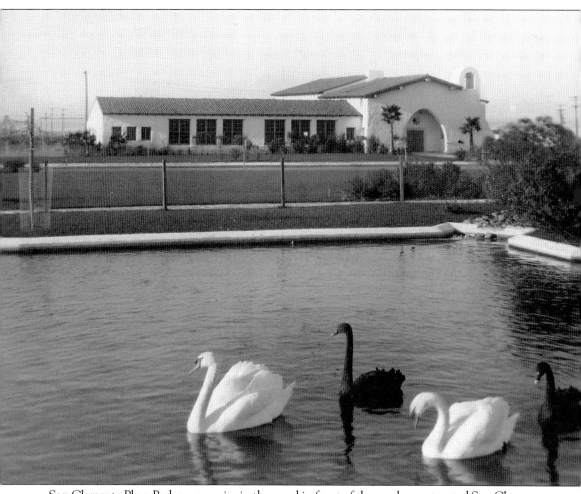

San Clemente Plaza Park swans swim in the pond in front of the newly constructed San Clemente Grammar School. White and black swans lived in the pond. The old grammar school, seen in the background, was demolished in 1971, due to structural damage from the 1933 earthquake. Before construction in 1927, San Clemente's few elementary schoolchildren received instruction from Bernice Haywood Ayer in a residence on Avenida Serra.

When the new San Clemente Grammar School opened, it was not immediately accredited to administer education by the State of California. City founder Ole Hanson built the school and deeded it to the homeowners of San Clemente; however, the county school district could not legally operate a "private" school. In an unprecedented move, a San Clemente School District was formed to handle the unusual situation. By 1935, enrollment had grown to 88 students, and the institution was renamed Las Palmas School, after the trees in Plaza Park, across the street.

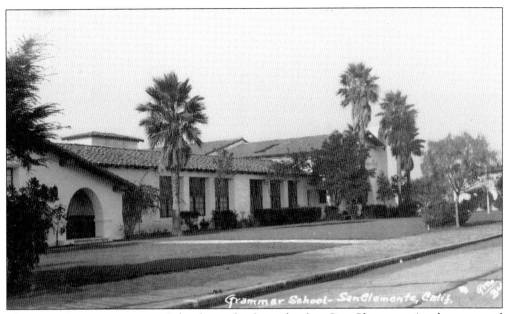

The San Clemente Grammar School was the first school in San Clemente. A side street and additional rooms were eventually added, as well as carekeepers' rooms upstairs. The school was given to the City of San Clemente by Ole Hanson and his partners and was in use by 1927. (Courtesy of Lois Divel.)

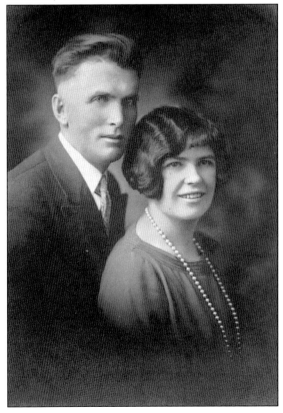

William Ayer and Bernice Hayward were photographed here as an announcement of their marriage. Ayer was San Clemente's first engineer. Hayward, a schoolteacher from Santa Ana, became the first schoolteacher in San Clemente, teaching out of a local home until the San Clemente Grammar School was built in 1927. (Courtesy of William Ayer.)

The address of Bernice Hayward's original schoolhouse was 157 Serra. The first class began with only five students, but attendance had increased by the time this photograph was taken. Many remember a group who used to call themselves the "Dirty Dozen," even though there were only four: Eugene (Bunny) Hanson, Lloyd Hanson, Bob Hanson, and Roy Divel. (Courtesy of William Ayer.)

Some students in Pauline Nedermeyer's first- and second-grade class of 1935, pictured here, were Eugene Ayer, Alex Jimenez, Beverly Milner, Mary Lou Hopkins, Skip Adair, Bill Morehouse, Lola Sanchez, Mrs. Nedermeyer, Doris Parker, Bona Jean Ray, Shirley Parker, Virginia Chambers, Joe Llamas, Jack Swigart, Bob Heywood, Fred Llamas, Ralph Longbotham, and Billy Ayer. (Courtesy of William Ayer.)

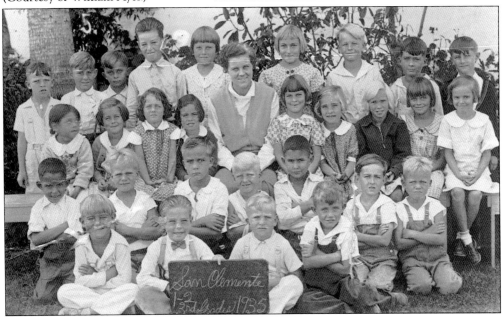

San Clemente Grammar School's kindergarten class of 1953–1955 pose with teacher Minta Hill for a class picture. As the city grew, so did the school. Since 1927, the school has had five reconstruction phases. In 1971 it was discovered the 1933 earthquake had caused structural damage, and it was determined to partially demolish the building and reconstruct it.

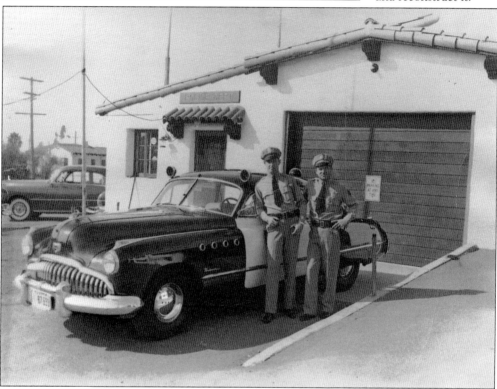

Officer Alex Jimenez and Chief Arthur (Artie) Daneri stand in front of San Clemente's first police and fire station at 104 Miramar, built in the early 1940s. In 1928, when the city was incorporated, only two officers were on the force—Chief Forrest Eaton and Harry Comber, the motorcycle officer. They operated out of a single room on the top floor of the Oscar Easley building, and the police chief shared a car with the fire chief. By the 1930s, San Clemente City Hall had taken over an existing building on Miramar and Del Mar, and the police department operated there until Chief Daneri and his officers helped build the fire/police station and jail behind the city hall on Miramar.

San Clemente was famous for the surf, the weather, and Bruce "Red Ryder" Crego. Before Interstate 5, San Clemente became known as a speed trap. Crego handed out approximately 350 tickets a week, but it was Bob Hope who created the legend. After he received his speeding ticket, he joked on his radio show, "The only way to make it past San Clemente without a traffic ticket was to swim or fly past." Bruce Crego, however, saved many lives, since El Camino Real was the only road between Los Angeles and San Diego, with no stops except for the 25-miles-per-hour section through the heart of San Clemente. The highway had been known as "Slaughter Alley." Crego got the nickname Red Ryder, after the tough redheaded comic strip character created by Stephen Slesinger in 1938, from locals who had seen him pull off whole groups of cars and make them wait for their ticket. His actions gained the respect of many.

The San Clemente Police Department went from two officers to a large force by the early 1960s. Unlike most cities, San Clemente's police force has had working relationships with the U.S. Marines and the U.S. Secret Service. The first police chief, Forest Eaton, assisted with the development of Camp Pendleton, and the department continues to work in solidarity with the U.S. Marines. The San Clemente Police Department was also integral in the efforts of the Secret Service during President Nixon's tenure in San Clemente in the 1970s. (Courtesy of Pat Bouman.)

The Palisades in San Clemente was part of Highway 1 or the Pacific Coast Highway. This is the area where Red Ryder would hide his car to catch speeders. The Pacific Coast Highway connects the coastal towns of California and is a favorite drive for visitors. (Courtesy of Lois Divel.)

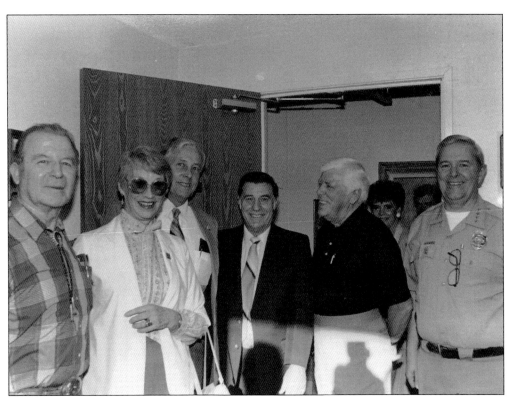

This reunion, in the San Clemente Police Department lobby, honored former police chiefs with portraits of each. From left to right are Chief Art Daneri (served from 1944 to 1958), Chief Mel Porter (served from 1958 to 1974), Betty Ray Weatherholtz (the first baby girl born in San Clemente), Lt. Mike Fisher, Sgt. Martin Cates, and Chief Al Ehlow (served from 1987 to 1992). (Courtesy of Pat Bouman.)

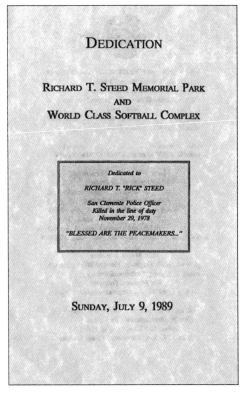

This program was for the 1989 dedication of the Richard T. Steed Memorial Park and Softball Complex. San Clemente has a history of people taking care of each other. The dedication of the softball field is representative of that kind of family. Rick Steed, who died in 1979, was the first and only San Clemente Police Department officer ever killed in the line of duty. (Courtesy of Pat Bouman.)

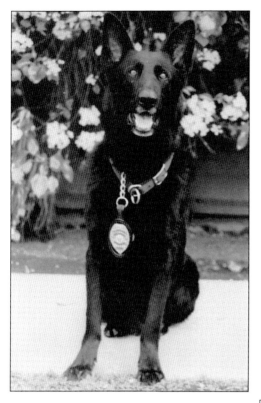

Officers come in all shapes and sizes, even in canine form. Sgt. Baron Von Willard, 1982–1988, was the first police K-9 in San Clemente. When the city was unable to come up with the funds to pay for a K-9 officer, the citizens of San Clemente raised the money through the Sonoptomist Club and private donations to sponsor the purchase of Baron Von Willard, the all-black German shepherd flown in from Germany. Jim Gularte, a police officer for San Clemente Police Department for 18 years and veteran of two tours in Vietnam, was Baron's handler during his service, and when Baron retired, Gularte became his owner. (Courtesy of Pat Bouman.)

Officer Jim Gularte and Burt Schiffer from City Parks pose at the dedication of the Sgt. Baron Von Willard Memorial Dog Playground (Dog Park). Greg Lipanovich started a nonprofit organization, which raised enough for the amenities and signage for the park. Lipanovich threw out the park's first tennis ball in September 2005. (Courtesy of Pat Bouman.)

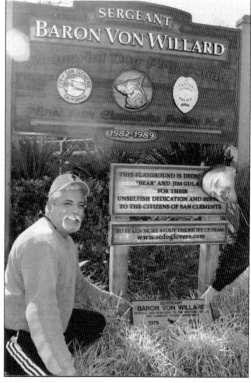

# Four

# THE VISITOR
## FOOD, LODGING, AND COMMERCE

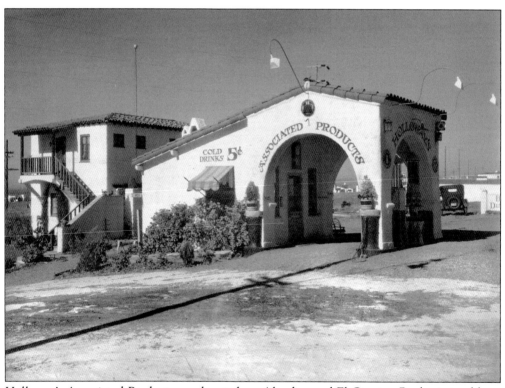

Holloway's Associated Products was located on Algodon and El Camino Real, pictured here around 1929. Before the I-5 Freeway was constructed, motorists drove down Highway 101 from Los Angeles. The Associated Service Station was open all night and offered aviation ethyl and Goodrich tires.

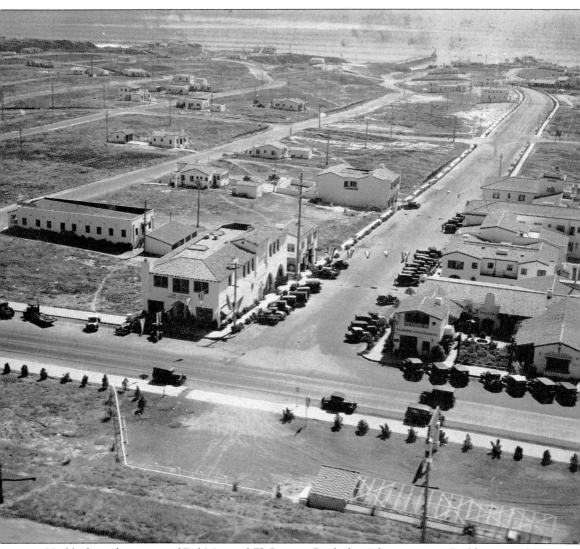

Visible from the corner of Del Mar and El Camino Real, the Administration Building was also known as Ole Hanson's Office. The first gas station located on El Camino Real is also visible, as are the Hotel San Clemente, Taylor Building, Antoinette Apartments, The Clubhouse, Coe Building, the Bartlett Building, and the flat-roofed Prado building. (Courtesy of Liz Hanson Kuhns.)

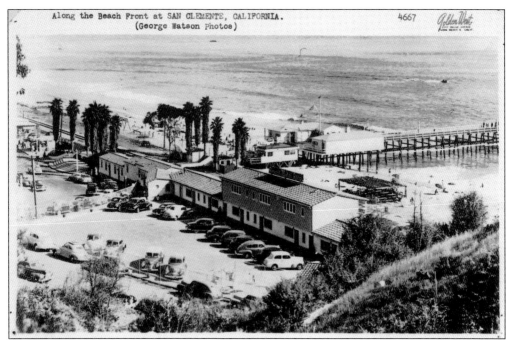

This is a view of the San Clemente Resort Motel and the bait and tackle shop around 1950. The motel resort was the perfect location for visitors to enjoy the Pier Bowl. In the 1970s, the city performed a controlled burn of the motel and area to build the Parque Del Mar.

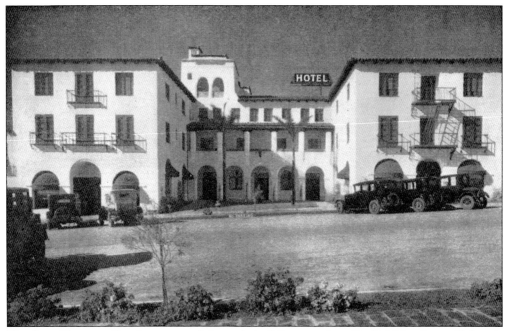

The San Clemente Hotel was one of the early buildings on Avenida Del Mar. James E. Lynch was its first owner. Many have stayed in the hotel, either while visiting San Clemente or just on their way between San Diego and Los Angeles. Stars from 1920s and 1930s Hollywood and other socialites vacationed here.

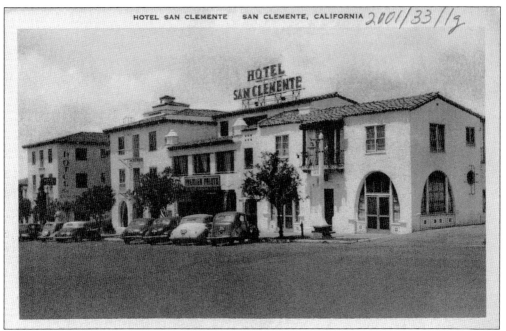

In the 1940s and 1950s, a neon sign was added to the hotel. Residents remember that it never seemed to have all the letters lit at the same time. The running joke was, "What is the hotel's name today?" Today the building is on the National Register of Historic Places. To the right is the Taylor Building. (Courtesy of Lois Divel.)

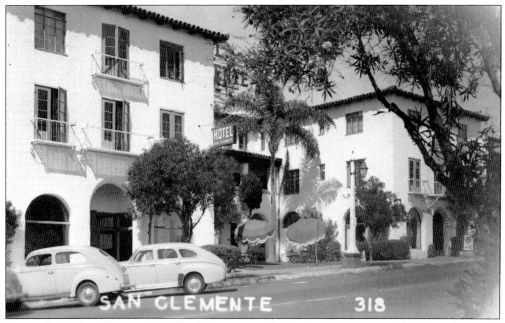

Originally the San Clemente Hotel had 60 rooms and baths. In 1976, the original 1927 configuration was changed and converted into 47 apartments. The central tower contains a carillon that is programmed to chime tunes daily.

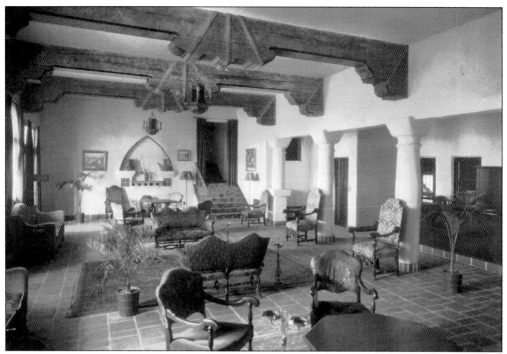

The interior of the San Clemente Hotel in 1927 was decorated with revival furniture and palms, appealing to the class of clientele expected to stay in the hotel. The staircase here in the center leads to the next level of rooms, and the door on the right is the elevator. Every room had electricity, and the charge per room was $2 a night and up.

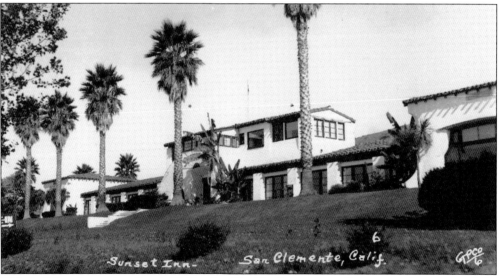

This building located at South El Camino Real had more transformations than most of the original buildings in San Clemente. First, as the San Clemente Riding Academy, the ornate and expansive building was a luxurious stable for some of the finest horses. After serving as the stables and the academy, the building was transformed into the San Clemente Hospital and was considered a "fancy home for sick people." Later it became a series of motels before its demolition in the 1970s.

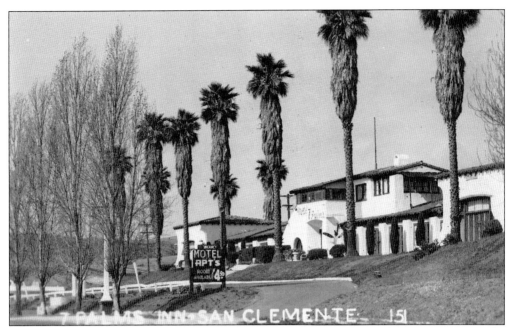

The 7 Palms Inn and Apartments, previously the Sunset Inn, was the final transformation of the building on South El Camino Real. From horse stalls to hospital beds to the Sunset Inn and the 7 Palms Motel, this building was versatile and beautiful. (Courtesy of Lois Divel.)

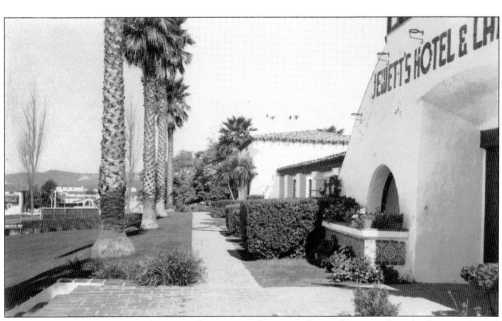

In another transformation, the San Clemente Riding Academy also served as the Jewett's Hotel and Café for a short time before it was demolished. (Courtesy of Lois Divel.)

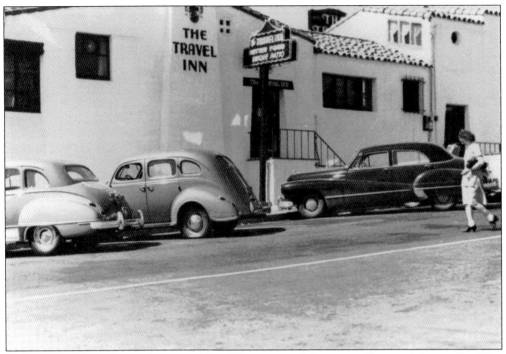

Visitors have always been a big part of San Clemente, and the town offers much hospitality. The Travel Inn became an important addition to the town's other hotels and motels, especially during the summer months.

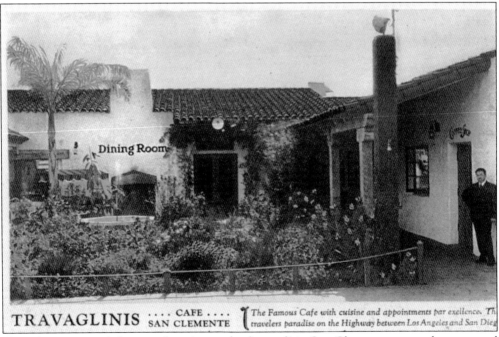

Travaglinis occupied the same location as the first café in San Clemente, across the courtyard from Ole Hanson's Office. It later became the Travel Inn and then, once again, a restaurant. (Courtesy of Lois Divel.)

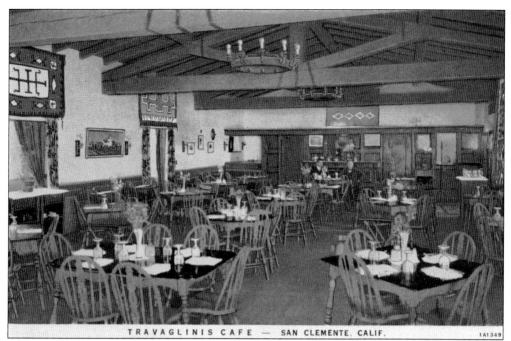

TRAVAGLINIS CAFE — SAN CLEMENTE, CALIF.

Pictured above is the interior of Travaglinis restaurant, known for its French and Italian cuisine. The ceiling beams were original to the San Clemente Café. The location of the restaurant, next to the service station on the corner of Avenida Cabrillo and North El Camino Real, provided visitors the chance to fuel the car, have dinner at Travaglini's Restaurant, and maybe even stay overnight at the San Clemente Hotel. (Courtesy of Lois Divel.)

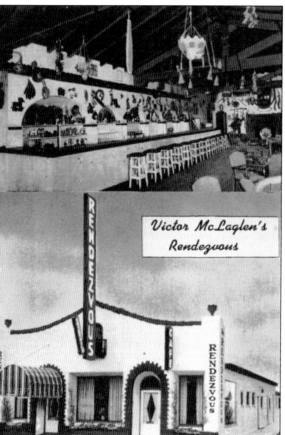

Victor McLaglen's The Rendezvous Restaurant, named after the British actor, is pictured here. Of the roughly 500 buildings constructed under Ole Hanson, more than 200 survive today, making San Clemente a heritage tourism destination.

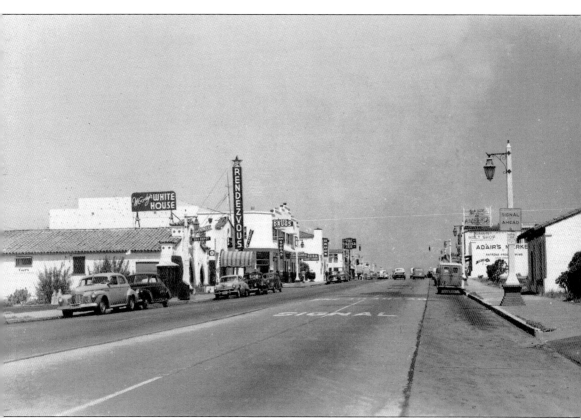

Pictured at left is Victor McLaglen's The Rendezvous Restaurant as seen from El Camino Real. When San Clemente was founded in 1926, the Prohibition era was already a reality. San Clemente immediately earned a reputation for illegal alcohol distribution due to its relatively isolated location along the Pacific coast. Large foreign vessels remained anchored just offshore in international waters. Local fishermen with fast boats were recruited as rumrunners to transport liquor from ship to shore, often at night.

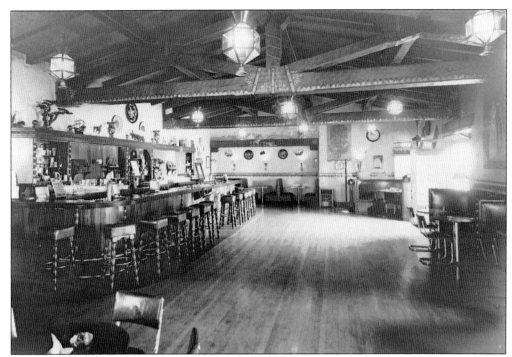

This shows the interior of The Rendezvous Restaurant. During Prohibition, San Clemente's homes' and restaurants' liquor cabinets were considered among the best-stocked in Southern California. Overindulgence sometimes led to arrests of entire caravans of out-of-town guests by the local police. Often the offenders were put up in local hotels.

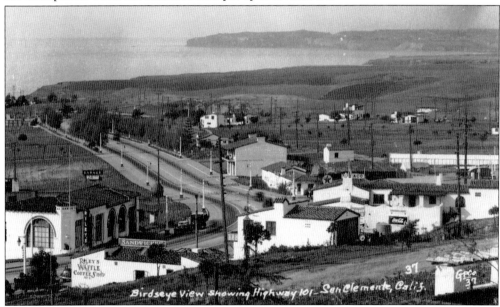

Pictured on the lower left is the popular Riley's Waffle shop. In 1937, John Riley owned another waffle shop in Laguna Beach. Lloyd Hanson remembers when asking "What's your secret?" Johnny would smile and say, "I've made the waffles the same for 20 years." Across the street is the garage that became the 401 El Camino Real City Hall from 1930 to 1960.

The Casino Building was constructed by the Strang brothers for $75,000 and opened in 1937. It featured dance bands and notable singers. Live radio broadcasts emanated from the West Coast's newest hot spot six nights a week, and the original cost of admission was 40¢. Many Hollywood celebrities visited the night club, including Judy Garland, who was enticed to sing one of her hits, "I Cried For You." Overlooking the beach, it had a nautical theme, air-conditioning, and the latest amplification system. The casino would become Sebastian's West Dinner Theater after World War II.

The Casino Building opened with a full cocktail bar and a circular floating cork dance floor, with changing lights, air-conditioning, and a "Patio of the Stars." A crowd of 5,000 dancers were on hand at the July 31, 1937, gala premiere of the "Pacific Coast's most beautiful dancing palace." Opening night featured Sterling Young and his famous Columbia Network Orchestra. Over the years, the building has been reconfigured as a U.S. Coast Guard station, Moose lodge, the Southampton Dinner Theater, Sebastian's West Dinner Theater, and the CHI Institute.

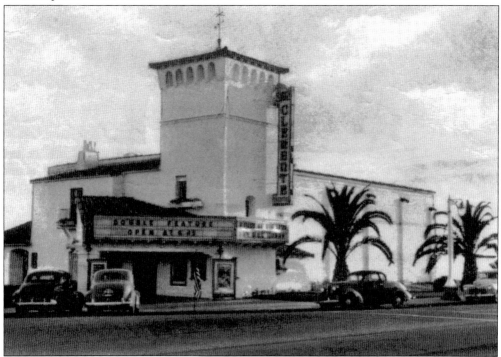

The San Clemente Theater would later be known as the Miramar Theater. Designed by architect C. A. Balch, it incorporated the Spanish tile and stucco of Hanson's dream. The theater's interior was comfortable and elegant.

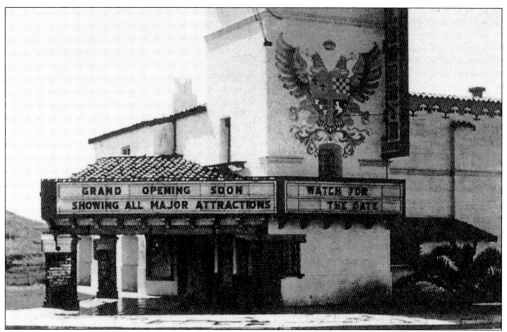

The Miramar Theater opened in 1938. This image of the theater depicts a Spanish-style crest on the theater's tower. Many local citizens who attended the opening and worked in the theater do not recall the crest ever actually being on the building. This picture may have been altered to be used as a promotional image.

The Golf Club Bar is where local vocalist Dorothy Fuller and others would perform. The bar was located in the first San Clemente Golf Course Clubhouse, erected in 1930 near the corner of Avenida Magdalena and South El Camino Real.

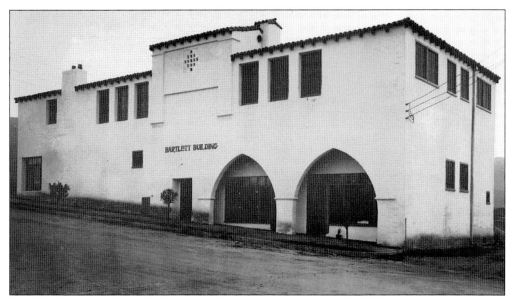

One of the first buildings built in San Clemente, across Avenida Del Mar from Ole Hanson's Office, was the Bartlett Building, which contained a general store, Carl Romer's hardware store, a barbershop, pool hall, lunch counter, and the San Clemente Café, owned and furnished by Ole Hanson, including a Florentine gilt mirror. The second floor contained furnished apartments.

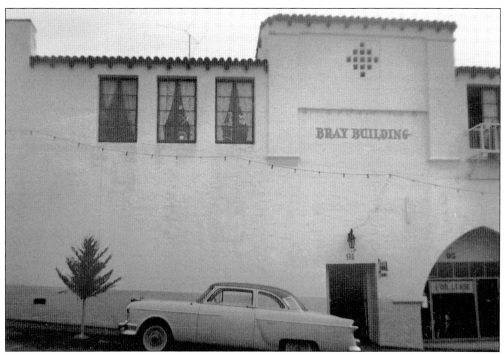

The Bartlett Building was constructed in 1926 and owned by Ed Bartlett. It became known as the Bray Building around the 1950s for a short time during a change in ownership. The building has housed a dental office and newspaper office, including San Clemente's first paper, the *El Heraldo* and the present *Sun Post News*.

The Madison Plumbing building was located on El Camino Real near Presidio. The mountains in the background date this photograph to January 1949, when it snowed on the hillsides of San Clemente.

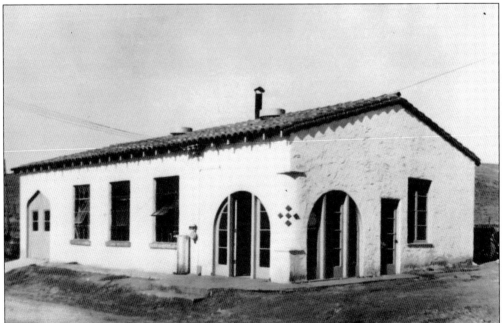

This building on Avenue Pico was where builders and furniture designers created the decorative wrought iron and Spanish Revival furniture needed by the young town. In 1927, San Clemente needed a factory to build furniture for the 300 newly constructed homes. Ole Hanson asked the furniture designers and craftsmen to use the upstairs of his office until he could build them a factory.

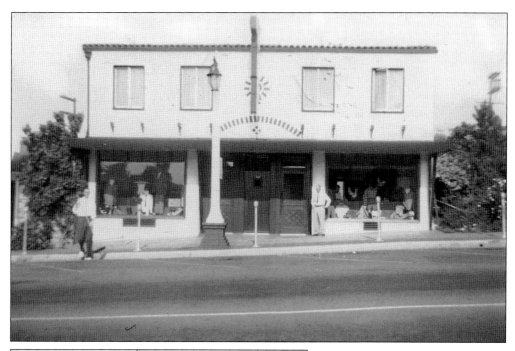

The Coe Building was also known as Lindy's, a men's shop, and later became home to the Heritage of San Clemente Foundation. Hanson's dream produced over 500 Spanish buildings until the 1930s and the Great Depression led to the abandonment of the "Spanish-only" building restrictions. Over 200 original "Spanish" buildings remain to this day, including this one.

Divel's Mortuary opened on El Camino Real. At that time, it was considered the "end of town." In 1927, when Roy Divel asked Ole Hanson if he could open a funeral home, Ole Hanson said, "If you have enough guts to open a business like that in a town of 300 people, I'll give you the building permit." Roy Divel also operated the only ambulance from Oceanside to Long Beach. Roy and Patti Divel both were very active in the community. (Courtesy of Lois Divel.)

The first gas station was built simultaneously with Ole Hanson's Office in 1926. The gas station was needed to fuel the equipment used to construct the new city and to supply prospective home buyers with fuel to drive between San Clemente and Los Angeles or San Diego.

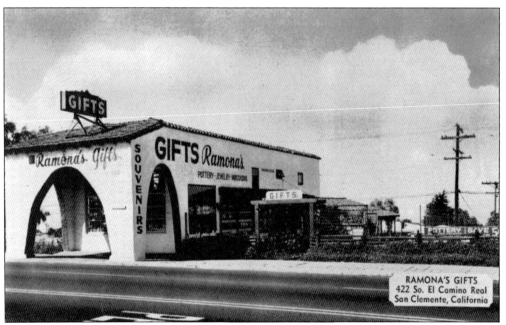

This building, located at 422 South El Camino Real, has since been demolished. It was called Gifts Unique. When the owner died, his wife continued the business and changed the name to Ramona's Gifts.

This building operated as a number of restaurants over the years, located at 211 North El Camino Real. The building to the right is a round orange juice stand, built around 1950. From the 1950s through the 1970s, the areas north and south of town were predominately orange groves. When driving through Orange County, one could actually smell them for miles.

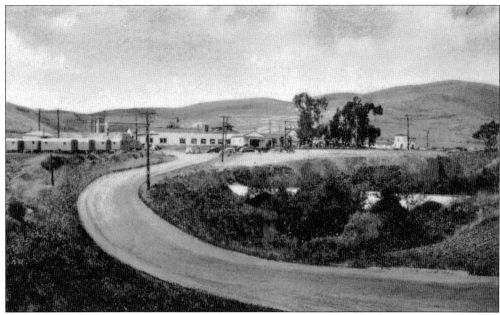

Reeves Rubber Factory was one of the first large industries to open in San Clemente. Lois Divel remembers sanding and buffing airplane parts at Reeves Rubber. Dave Tansey remembers walking to Reeves Rubber Factory and working the swing shift as a press man, making swim fins and parts for P38 fighter planes.

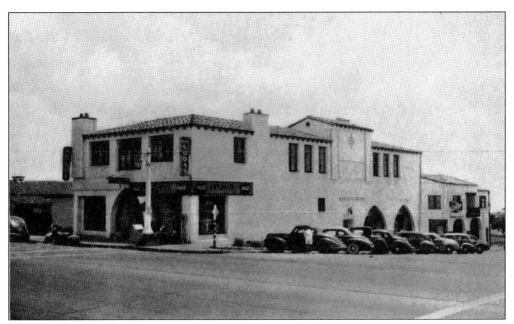

Fuller's Pharmacy was in the Bartlett Building for a while before moving down the street. Also located in the Bartlett Building was *El Heraldo de San Clemente*, San Clemente's first newspaper, begun by Ole Hanson.

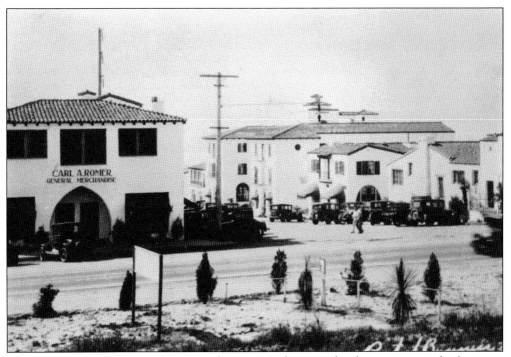

The top of Del Mar is pictured in the early 1930s. Carl Romer's hardware store was the first store to occupy this site. It later became a market and a pharmacy.

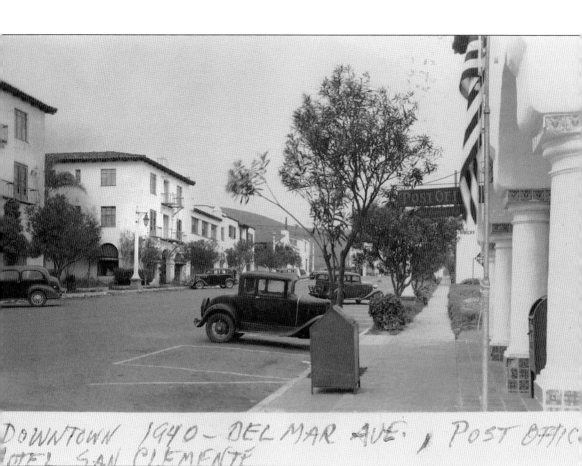

Looking up Del Mar in 1940, the Hotel San Clemente is visible on the left and the post office stands to the right. With a vision of building an entire village "in the fashion of Old Spain," Hanson wrote, "We believe beauty to be an asset as well as gold or silver. . . . We may build at San Clemente but one building, but we will preserve for all time these hills from the heterogeneous mixture of terrible structures which so often destroy the beauty of our cities."

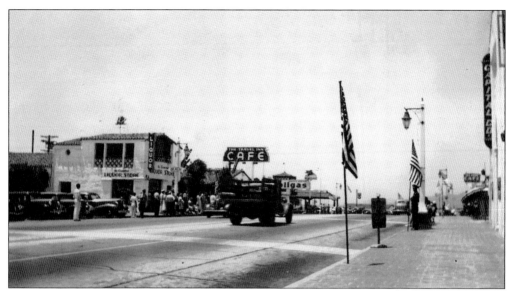

This is where El Camino Real intersects the end of Avenida Del Mar. The top of the hill is fondly called the Top of Del Mar. The Marines are present in this photograph, as people are getting ready for President Roosevelt's motorcade to Camp Pendleton for the dedication. (Courtesy of Lois Divel.)

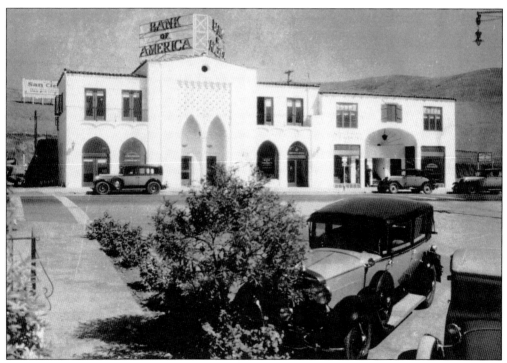

The Oscar Easley building became the Bank of America building during the Depression and remained so through the 1960s. The building fits the Spanish Revival architectural theme required by the Ole Hanson Organization. However, this building accentuates Moorish architectural elements more than any other building in town.

Del Mar Ave. San Clemente, Calif.

This shows the view looking up to the top of Del Mar at the Oscar Easley Building. The city's first street builder and contractor, Oscar F. Easley, had surveyed the location and concluded that the city plan would probably fail, but he decided to have faith and "ride through with the boss," founder Ole Hanson. Hanson wanted to have "a village in the fashion of Old Spain," rather than one of California Mission or Mexican village style. Easley went on to build a number of buildings for himself. One can still see Easley's handiwork on curbs all over the downtown area. Just look for an imprint on the curb that says, "OF Easley Contractor."

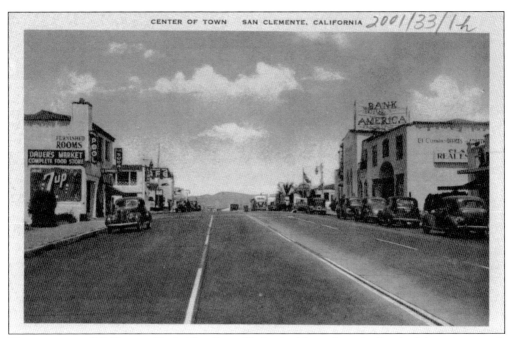

This is a view of El Camino Real. The Oscar Easley building, then the Bank of America, stands on the right, with a real estate office next to it. On the left side of the street, the Bartlett Building contains furnished rooms for rent and a café with pool tables. Ole Hanson's Office is seen on the corner.

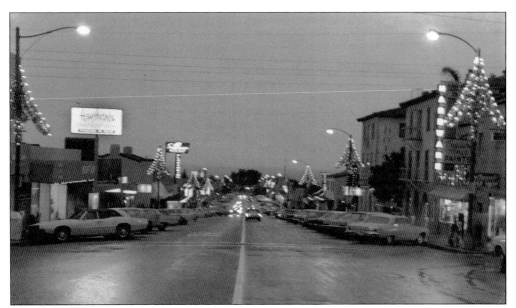

Looking down Avenida Del Mar at night, this photograph shows Del Mar covered in lights. Just about every shop owner decorated with lights during the holidays, and the city decorated lampposts and trees, a tradition that exists today.

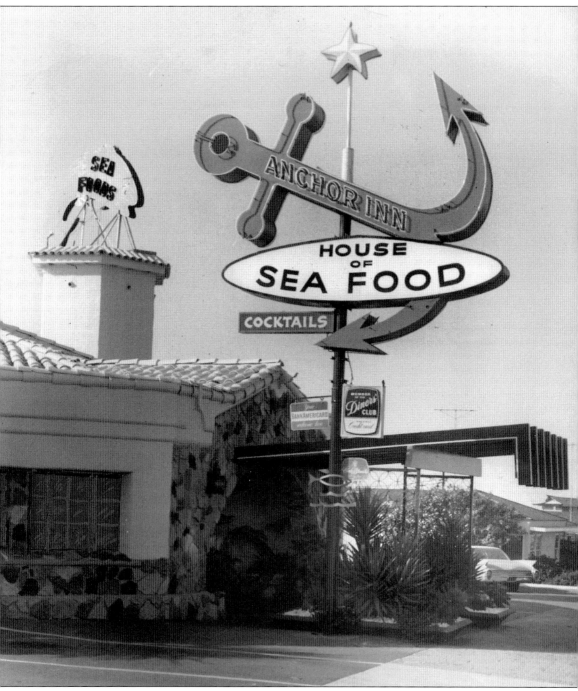

The Aquarium Café was one of a kind during its day. Built into the walls were huge saltwater tanks full of sealife. Fresh ocean water was pumped into them daily in this seafood restaurant. The Aquarium Café opened just as the Depression hit. The owner, Mr. Servus, was so distraught that he hung himself in the back bedroom; however, his wife, Emma, was determined to succeed, and she continued the restaurant successfully. It later became the Anchor Inn and then several other restaurants.

The 1960s brought about new architecture. The building requirements for Spanish-tiled roofs were removed in the early 1940s, giving rise to modern architecture with flat roof tops, streamlined and angled architectural elements, and plenty of windows. Since the 1990s, downtown San Clemente's devotion to Ole Hanson's Spanish Colonial Revival style has returned by virtue of an Architectural Overlay District.

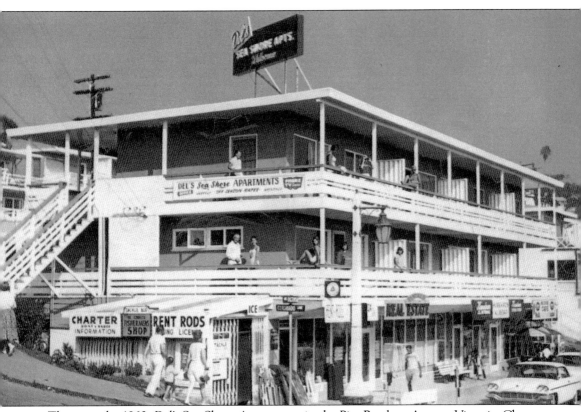

These are the 1960s Del's Sea Shore Apartments in the Pier Bowl on Avenue Victoria. Charter fishing boats could be rented for the day, or one could spend the day on the beach. Dave Tansey recalls for the *75th Anniversary of San Clemente Life Guards*, "Don Divel kept folks out of trouble under the pier. It was probably during 1944 or 1945 when Marv Crummer was captain of the guards. Opie (Tommy Wert) was the longtime guard. The guards on regular duty during that era were Hal Sachs, Jerry Martin, Terry DeWolfe, and me. [In] those days, we also guarded San Clemente State Park, Cottons Point, Doheny State Park, and the old train station at the north end of town."

# Five

# THE PARTIES
## EVENTS AND GAMES

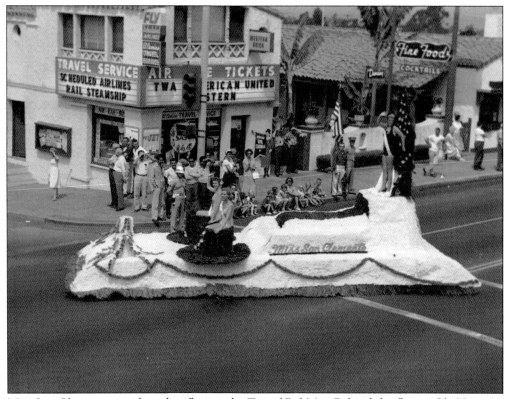

Miss San Clemente travels on her float at the Top of Del Mar. Behind the float is Ole Hanson's Administrative Office Building. The courtyard is open between the office building and Travaglinis Restaurant. The parades frequently included Marines from Camp Pendleton.

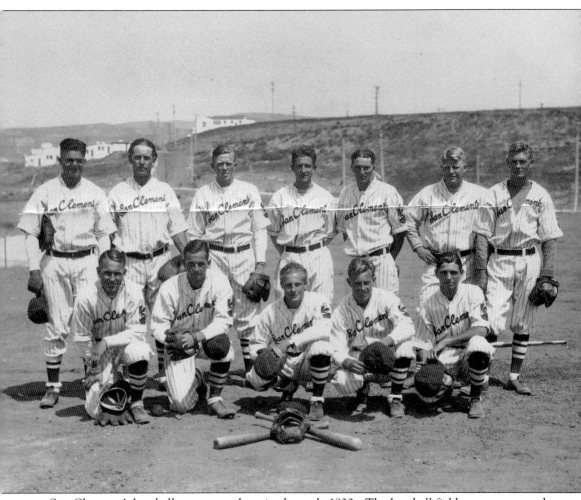

San Clemente's baseball team poses here in the early 1930s. The baseball field was constructed near North Beach and was used for spring practice by the Seattle Indians, a team from the Pacific Coast League, until San Clemente had its own Pacific Coast League team in 1927. Bob Meusel, Yankee outfielder, said the San Clemente field was the best in America. (Courtesy of Liz Hanson Kuhns.)

Community events have been a long-standing tradition for San Clemente, a way for people to relax, reconnect with friends, and celebrate. The city has an old tradition of encouraging and providing community programs, some old and some new. One is the Ocean Festival. Depicted here is the annual sand castle building contest.

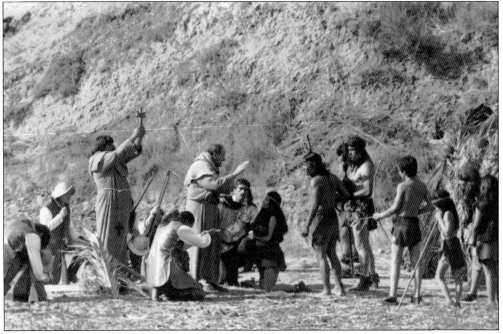

One of the oldest community events was the Parade of Fiesta La Cristianita, parade and play depicting the Spanish and Acjachemen meeting in the canyons off Cristianita and the location of the first baptism in California. In the past, players have been residents of San Clemente, including the Acjachemen people.

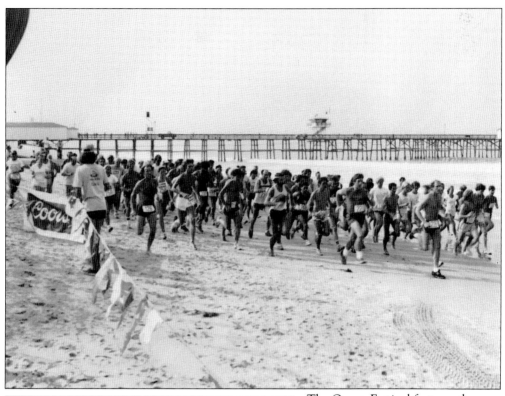

The Ocean Festival features three days of aquatic and endurance competitions as well as art and craft competitions. This race is one of the only Festival 5K Beach Run/Walks of its kind in Southern California.

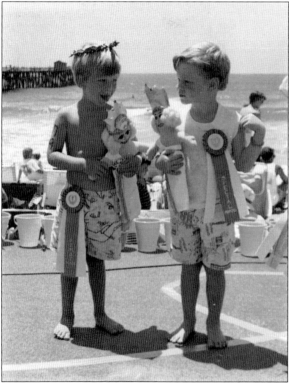

Two award recipients pose here, possibly from one of the children's events. Some of the events over the years have been the Great Rubber Duck Race and the Kids Fishing Derby, Sand Sculpture, Body Surfing Championships, Annual Woody Car Exhibit, and the Stand Up Paddleboard Surfing Competition. Also included were pancake breakfasts and fishing clinics.

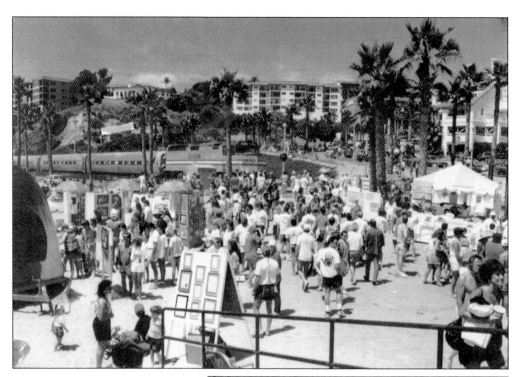

San Clemente hosts an arts and crafts fair on Avenida Del Mar the first Sunday of every month. The Ocean Festival and the Fiesta Festival also offer the opportunity for artists and businesses to share their wares.

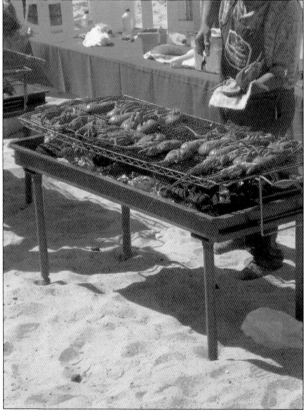

The Seafest event in San Clemente is known for its Chowder Cook-Off Competition, where businesses and families compete for the best chowder. The chowder is judged on a point basis for overall Best Tasting Chowder, the Best Decorated Booth and the People's Choice Award. A variety of foods are available for tasting, as seen here at this grilled lobster booth on the beach.

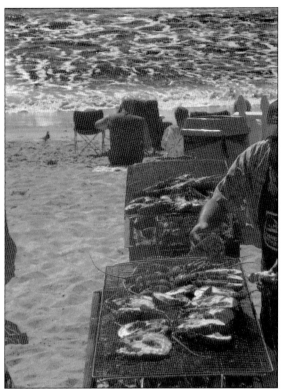

In keeping with Ole Hanson's dream for a community that shares in all its amenities, some of the events started by a number of citizens and various organizations have continued for years, including the free summer beach concerts, the Open Skate and Surf Contest, Street Faire, the Ocean Festival, Fourth of July fireworks show, Memorial Day observances, Seafest, Cinco De Mayo, Community Garden Fest, Community Easter Brunch, Springtacular, Flashlight Frenzy, St. Patrick's Day Dinner Dance, Mayor's Prayer Breakfast, Day of Your Dreams, Christmas Gift Exchange Program, Christmas at the Casa, Holly Jolly Hoopla, Puttin' on the Glitz, Historic Home Tours, Art Walk, and the monthly Village Art Fair, to name a few.

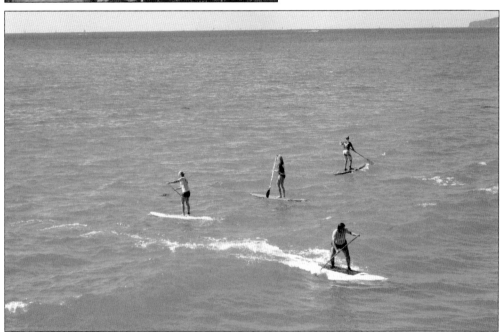

These young women, some of them members of the San Clemente High School Surf Team, compete in the Stand Up Paddleboard Surfing Competition at Seafest. San Clemente High School has one of the nation's top surfing programs, winning numerous NSSA national surfing titles. San Clemente High School opened in 1964, with its first graduating class in 1965.

# Six

# THE RESIDENCES
## HOMES AND RETREATS

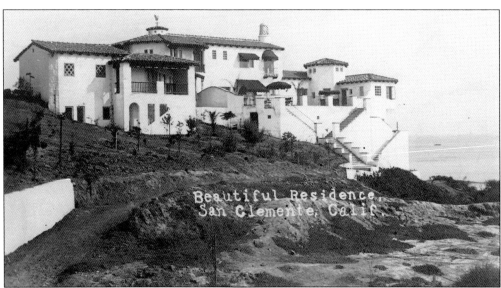

I. M. Bartow's home overlooked the pier. The Bartow house became known as more than a beautiful historic home as it became synonymous with the start of the San Clemente Historical Society. It was considered the most beautiful of the bluff mansions built in the "Pasadena Colony" at Cazador Lane and Pasadena Court. Images of this home constructed by I. M. Bartow were used in Chamber of Commerce literature as the symbol of San Clemente. After being denied a permit to demolish the historic building in 1972, the property's owners bulldozed the building in the middle of the night, antique furniture and all. A short time later, the city approved a permit to build 45 condominiums at the site. Longtime resident, photographer, and historical society pastpresident Dorothy Fuller remembers, "It was a gorgeous home." (Courtesy of Lois Divel.)

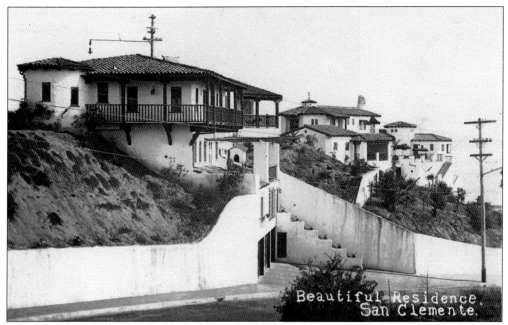

Seacliffs Villa is in the foreground, and the Bartow house is in the background. These two stately homes were designed in the required Spanish Revival style. Each was located on prime property, featuring views of the ocean and pier, with constant ocean breezes. Landscaped gardens, interior patios, Spanish tilework, woodwork and ironwork, all crafted in San Clemente, made up each home. (Courtesy of Lois Divel.)

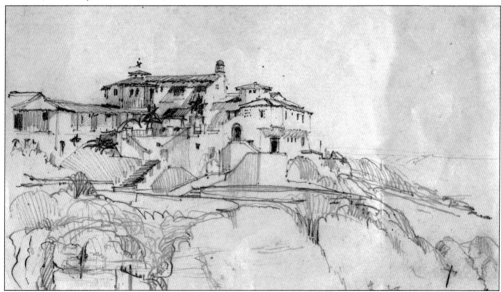

This is an original sketch by Virgil D. Westbrook of what appears to be the Bartow home. Westbrook, who came to San Clemente after serving in World War I, was already an accomplished architect in Santa Barbara and Los Angeles. He created inspired architectural buildings within the parameters of Ole Hanson's dream. Westbrook buildings follow the Spanish Revival style with a delicacy not seen in other buildings. The lines of the buildings are fluid and curved. The structure of the building is proportioned evenly, giving every building a solid but special appearance.

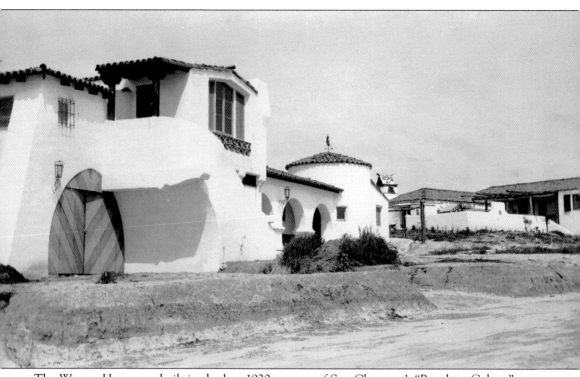

The Warner Home was built in the late 1920s as part of San Clemente's "Pasadena Colony" on Cazador Lane. This structure was home to Judge Fred A. Warner and his wife, Elena. Warner was the first municipal judge in the new city of San Clemente. Judge Warner's brother, Glenn, lived upstairs. The judge was active in the city's affairs and founded the San Clemente Chamber of Commerce. An adamant enforcer of Prohibition, the judge was astonished one day to find liquor secretly stashed under his house. This beach house, also known as "Casa Del Cazador," was built by the Strang Brothers and features 2,850 square feet of interior on a double city lot. Judy Warner's brother was also known as "Pop" Warner. Glenn was a football Hall-of-Famer and would become most famous for his youth football activities and the leagues that continue to carry his name today.

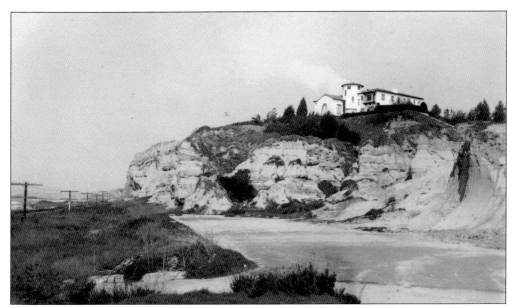

A. T. Smith's home was a beautiful estate located near what is today San Clemente State Park. A. T. Smith was a former mayor of San Clemente. Phil Smith, his brother, owned the water rights in Lone Pine and Bishop in Northern California. His sisters occupied the house for years, each living in her own section of the house. (Courtesy of Lois Divel.)

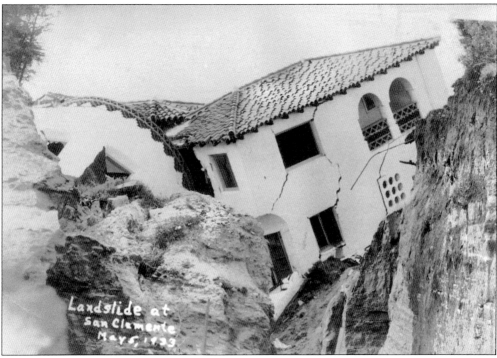

The 1933 earthquake happened to occur at the same time that Ole Hanson and Thomas F. Murphine were in the middle of political disagreements. Unfortunately, Murphine's home was built on a shallow fault line, and the beautiful home was consumed by the fissure created.

Orange County Superior Court Judge G. K. Scovel ruled that "Spanish-style architecture only" could not be literally enforced. Afterwards, the Bank of America transferred 2,400 building lots to the Capital Company of Los Angeles for construction in any style.

The first homes to be built under the new ruling were the Ranch Homes for Reeves Rubber employees, some of whom worked sanding and buffing airplane parts. Posed in the picture is San Clemente resident Betty Sue Jones.

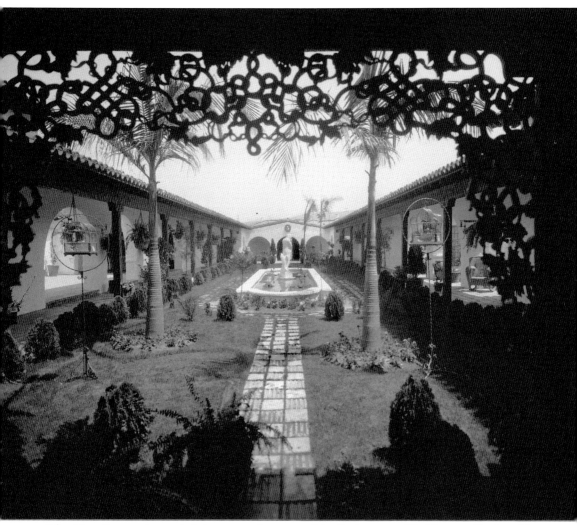

The Casa Romantica, as it is known today, was originally home to Ole Hanson. Designed by architect Carl Lindbom, the 15-room structure featured a Moorish keyhole arch main entrance and was built around a Spanish courtyard with a large pool and fountain. Each side of the interior entry to the parlor was decorated with Norman Kennedy murals. An outdoor barbecue area, dance floor, and fancy birdcages completed the exotic ambiance. The Hanson family lived in the splendid residence for less than five years before the Great Depression finally forced many properties into foreclosure. (Courtesy of Liz Hanson Kuhns.)

Pictured here is the interior and fully enclosed courtyard, or solarium, in the Casa Romantica, looking into the living room. The living room's main focus was its large fireplace. Ole Hanson was concerned that the dampness would cause problems for his son Ollie, who had suffered from tuberculosis; the fireplace helped keep the rooms dry. (Courtesy of Liz Hanson Kuhns.)

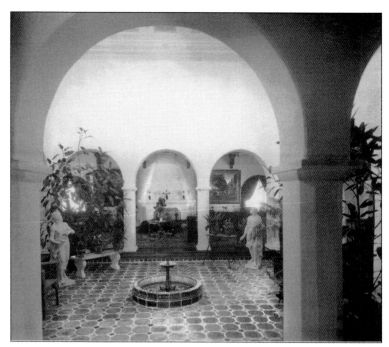

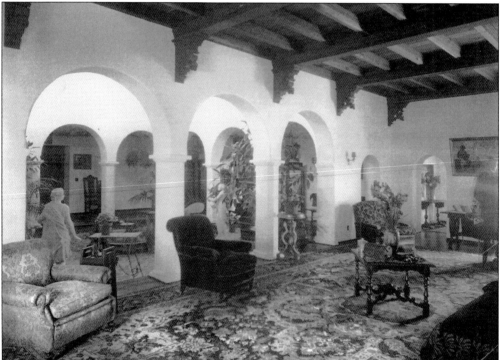

The interior of the Casa Romantica is pictured here from the living room. Opposite the solarium, the home opened onto a porch with an outdoor dance floor. From this location, the pier bowl and the Pacific Ocean are visible. Lloyd Hanson recalls that parts of San Clemente sometimes visible from the home were used by the U.S. Navy for artillery practice and that the vibrations "cracked the walls." (Courtesy of Liz Hanson Kuhns.)

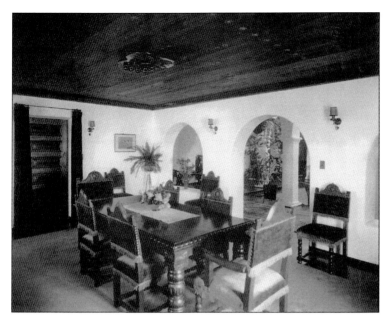

Pictured here is the dining room of the Casa Romantica, with the solarium visible through the archways. Lloyd Hanson recalls they had a butler, just as their friend Hamilton Cotton did. He recalls that it took his dad some time to realize that he had a button under the table to call the butler when it was time to clear the table. (Courtesy of Liz Hanson Kuhns.)

Pictured here is the interior of the Casa Romantica from the solarium, looking into the dining room. Hanson referred to his home simply as "the house." A later resident dubbed it the Casa Romantica. (Courtesy of Liz Hanson Kuhns.)

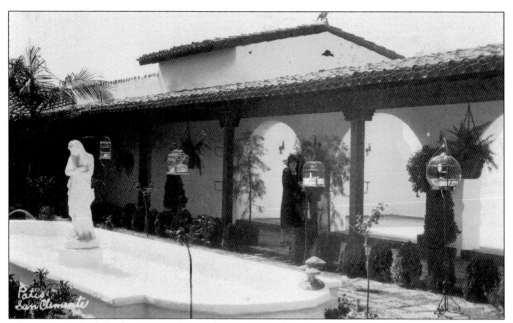

The courtyard of the house was located in the middle, with 20 rooms on all sides. Many of the homes had ponds with goldfish. However, Lloyd Hanson recalls the day they were given four baby alligators, which promptly ate the goldfish. The Hansons also surrounded themselves with birds, peacocks, chipmunks, and a monkey. (Courtesy of Liz Hanson Kuhns.)

Through the 1940s, Ole Hanson's House became home to the local wildlife. Left unattended, raccoons, skunks, mice and owls would frequent the beautiful home. The next owner, Nora Schuyler, wrote a children's book about it, called *Life at the Casa Romantica*. One of the new owners filled in the pond, as seen here. (Courtesy of Liz Hanson Kuhns.)

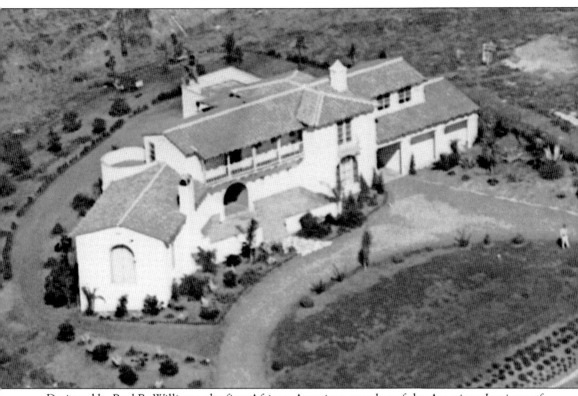

Designed by Paul R. Williams, the first African American member of the American Institute of Architects, this home was commissioned by the Goldschmidt family to be their weekend home. Planning to run cattle, Herman and Max Goldschmidt had partnered with Cornelio Echenique to purchase 10,500 acres of the old Rancho Los Desechos Spanish land grant from the Forster family in 1906. The coming of Prohibition in 1920 led to a breakup of the partnership, with the Goldschmidts taking the coastal strip of the old rancho. In 1924, a syndicate led by Hamilton Cotton purchased the Goldschmidt grazing land for $7 million. Soon thereafter, Ole Hanson took over the acreage to found San Clemente. The Goldschmidts purchased the highest elevation lot in the new city, with views of the new Spanish village, the hills, and the ocean. It remains largely original to this day, including a hidden room with a liquor bar. It is the only residence in San Clemente to be listed on the National Register of Historic Places.

Here are the Casa Pacifica Courtyard and Stairway of Henry Hamilton Cotton's home, built in 1926 and 1927 by Carl Lindbom. Today the home is known as La Casa Pacifica. It has been host to two sitting U.S. presidents. The first president to visit the estate was Franklin Delano Roosevelt, a close friend of Hamilton Cotton. FDR would arrive on a private Santa Fe Railway car and be carried from the train track up the back steps to the home in his wheelchair to play poker with his friend.

The second U.S. president to be associated with the Cotton estate was Richard M. Nixon, who purchased it from Cotton's widow in 1969. The courtyard welcomed not only presidents but many other dignitaries and heads of state, both foreign and domestic. The Nixons enjoyed it as the Western White House during his presidency and as their home until 1980, when it was sold to Nixon's friend, Gavin Herbert. The centerpiece of the courtyard, which remains there today, was the brightly colored tile fountain topped with a sculpted cherub.

# Seven
# THE PRESIDENT
## WHEN NIXON MOVED IN

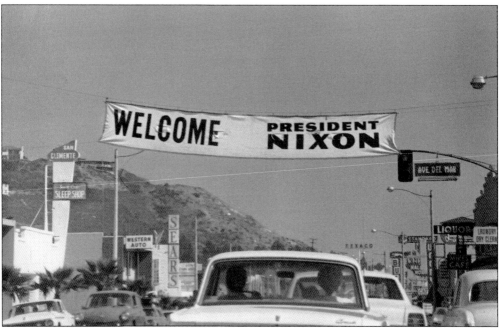

Two months after taking office, President Nixon and the first family were looking for a spot in California to use as a Western White House. Fred Divel, grandson of Roy Divel, who was one of the first residents, had been a volunteer in Nixon's presidential campaign in San Clemente and suggested the H. H. Cotton estate. Fred Divel sent photographs of the estate to Nixon's advisor John Erlichman. Within a few months, the Nixons purchased the home from Hamilton Cotton's widow as their private residence and called it La Casa Pacifica. This is the welcome banner at El Camino and Del Mar. (Photograph by Doris Walker; courtesy of Pat Bouman.)

*Welcome to La Casa Pacifica*

*Richard Nixon*
*Pat Nixon*

February 26, 1978

Souvenir of the City of San Clemente's 50th Birthday

In 1978, San Clemente celebrated its 50th birthday and the Nixons participated. The H. H. Cotton estate, now the home of a sitting President, had to be outfitted with Secret Service and communication devices. New phone lines were put in. The H. H. Cotton Gazebo where FDR would play cards was now a Secret Service post. A U.S. Navy ship sat off shore day and night to protect the country's leader. (Courtesy of Pat Bouman.)

This is La Casa Pacifica or the Western White House in 1971. President Nixon, Pat Nixon, daughter Julie and her husband, David Eisenhower, stand at the entrance of their new San Clemente home. Most of the furnishings were brought from their former New York apartment. David and Julie used the adjoining small guest cottage when they visited, while daughter Tricia had a room in the main house. (Courtesy of Pat Bouman.)

President Nixon would on occasion try to slip out of sight without his usual entourage. He might be found meeting with community residents, either in front of a shop on Del Mar or, as pictured here, at Concordia School talking with schoolchildren. The photograph is signed by President Nixon to Marguerite Sheets, a Concordia teacher. (Courtesy of Pat Bouman.)

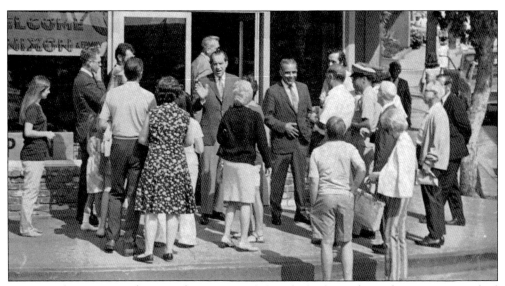

Here President Nixon is shopping downtown with friend Charles "Bebe" Rebozo in 1970. He had just purchased a box of chocolates for wife, Pat Nixon, and stopped to chat with local residents before returning to the Western White House to spend Memorial Day Weekend with his family. (Courtesy of Pat Bouman.)

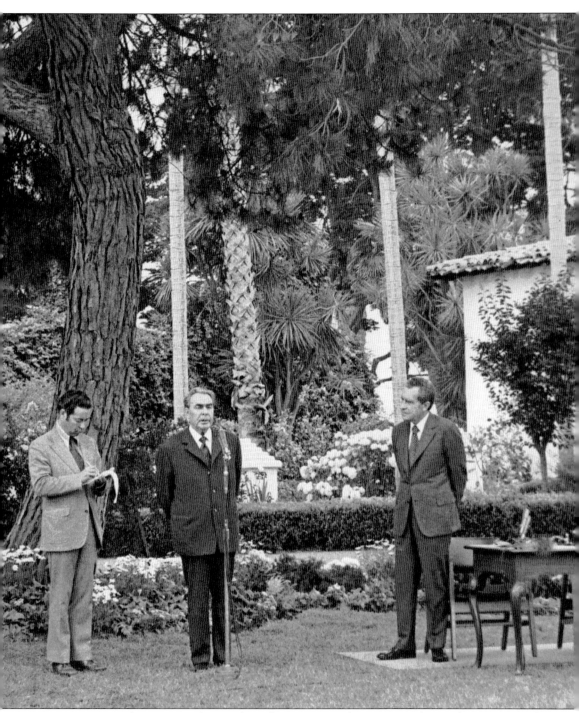

In June 1973, after meeting first at the White House and Camp David, President Nixon and Premier Brezhnev flew to San Clemente, where the talks continued. After many drinks, they retired. Brezhnev retired to Tricia's room, decorated in girlish motif, after he refused the presidential accommodations at Camp Pendleton. His security guards stayed in Julie's room. (Courtesy of Pat Bouman.)

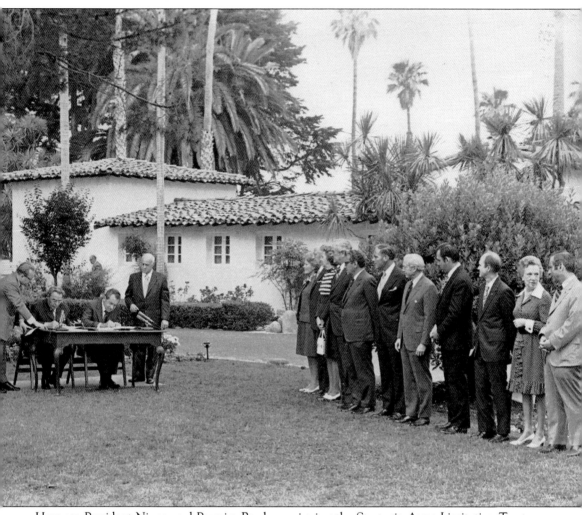

Here are President Nixon and Premier Brezhnev signing the Strategic Arms Limitation Treaty (SALT) outside San Clemente's Western White House in 1973. Nixon gave a formal speech after their successful meeting. "We think it is most appropriate that we meet here in California. The name of this house is La Casa Pacifica, which means 'The House of Peace.' As we look back to this day, we hope that this name, 'The House of Peace,' will be a reality—a reality in terms of the agreements that have been reached and in terms of the promise those agreements mean for not just the Soviet people and the American people but for all the people of the world." (Courtesy of Pat Bouman.)

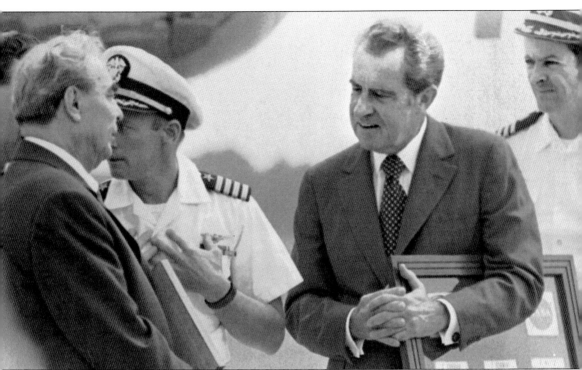

President Nixon and Premier Brezhnev greet astronauts in San Clemente at the H. H. Cotton home and Western White House in 1973. Richard Nixon was in the White House when Neil Armstrong and Buzz Aldrin walked on the moon on July 20, 1969. The astronauts placed a plaque bearing President Nixon's signature and an inscription reading: "Here men from the planet Earth first set foot upon the Moon July 1969 AD. We came in peace for all mankind." (Courtesy of Pat Bouman.)

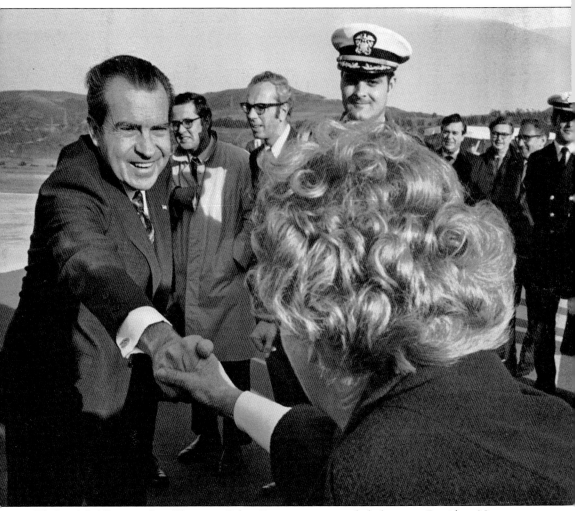

Thelma McAllister, a San Clemente Police Department record clerk, greets President Nixon as he arrives by his helicopter, Chopper 1, at the Western White House helipad in 1971. McAllister was leaving the SCPD, and her only departing wish was to meet the president. President Nixon gladly obliged when the chief of police made the request to him. In 1987, former president Nixon wrote to the *Daily Sun Post*, "Mrs. Nixon and I have many pleasant memories of the years we lived in San Clemente and of the people there we were privileged to meet and know." (Courtesy of Pat Bouman.)

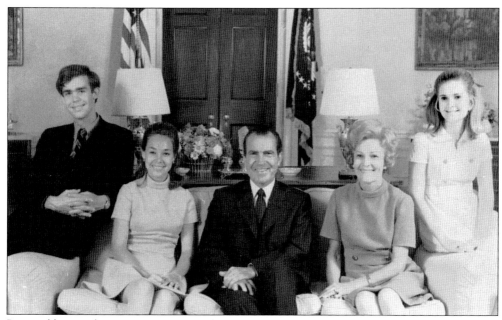

Pictured here is the next generation of the Nixon family. Julie and David Eisenhower eventually moved to the area and had their first baby, Jennifer, at San Clemente General Hospital. David Eisenhower rented office space in the Bartlett Building on the corner of Del Mar and El Camino Real, where he wrote the biography of his grandfather, Pres. Dwight D. Eisenhower. (Courtesy of Pat Bouman.)

Camp Pendleton has always had a significant relationship with San Clemente. From its inception with the Forster, O'Neill, and Pico families to Franklin Delano Roosevelt, to Nixon's White House, San Clemente's neighbors to the south have been there to assist the San Clemente Fire Department and now the Orange County Fire Authority in firefighting. They have participated in San Clemente parades and have sent their children to San Clemente schools. It is fitting that San Clemente would honor them in 2005, through the efforts of The Heritage of San Clemente Foundation, with the Park Semper Fi Marine Monument. (Courtesy of The Heritage of San Clemente Foundation.)

San Clemente is known to visitors for its sandstone cliffs, its cattle rancheros, its founder who dreamed of building a city that follows the contours of the landscape, its visionary architects, its presidents—both Democratic and Republican, its surfers and skateboarders; but it will always be known by its residents as home.

# Discover Thousands of Local History Books
## Featuring Millions of Vintage Images

Arcadia Publishing, the leading local history publisher in the United States, is committed to making history accessible and meaningful through publishing books that celebrate and preserve the heritage of America's people and places.

Find more books like this at
**www.arcadiapublishing.com**

Search for your hometown history, your old stomping grounds, and even your favorite sports team.

Consistent with our mission to preserve history on a local level, this book was printed in South Carolina on American-made paper and manufactured entirely in the United States. Products carrying the accredited Forest Stewardship Council (FSC) label are printed on 100 percent FSC-certified paper.

MADE IN THE USA